This book belongs to

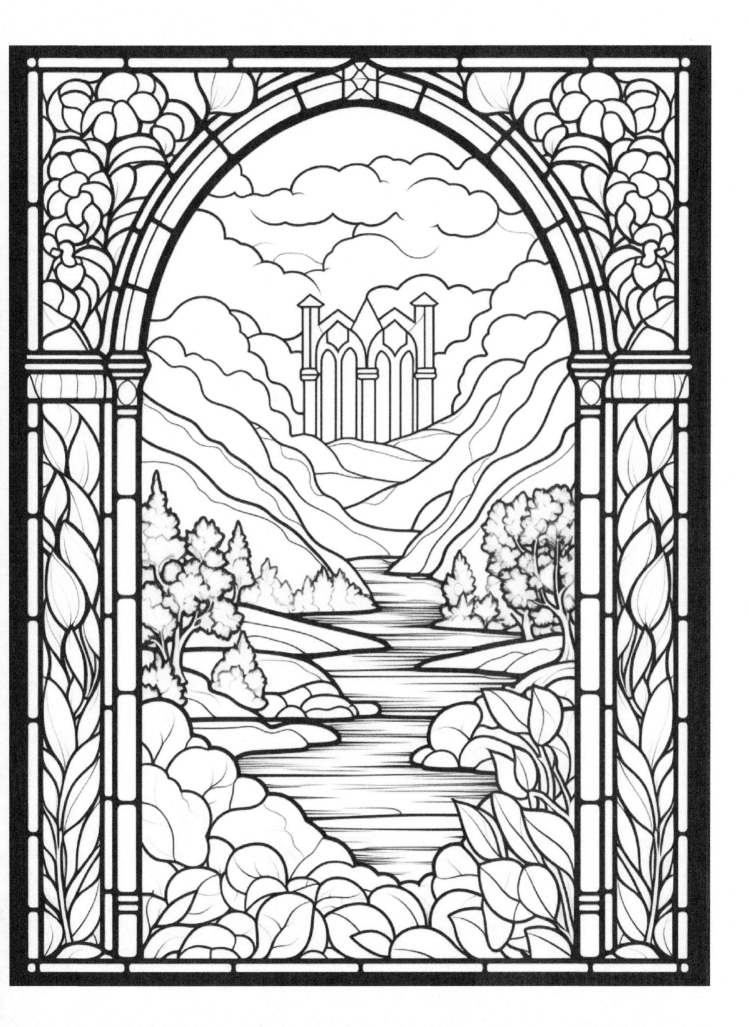

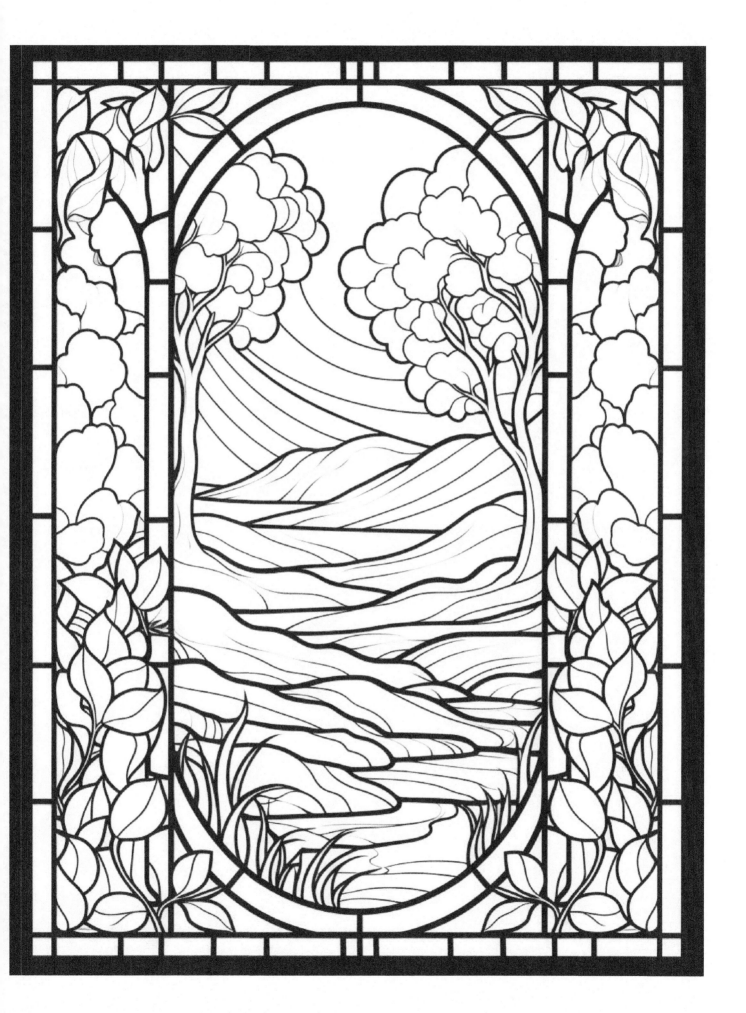

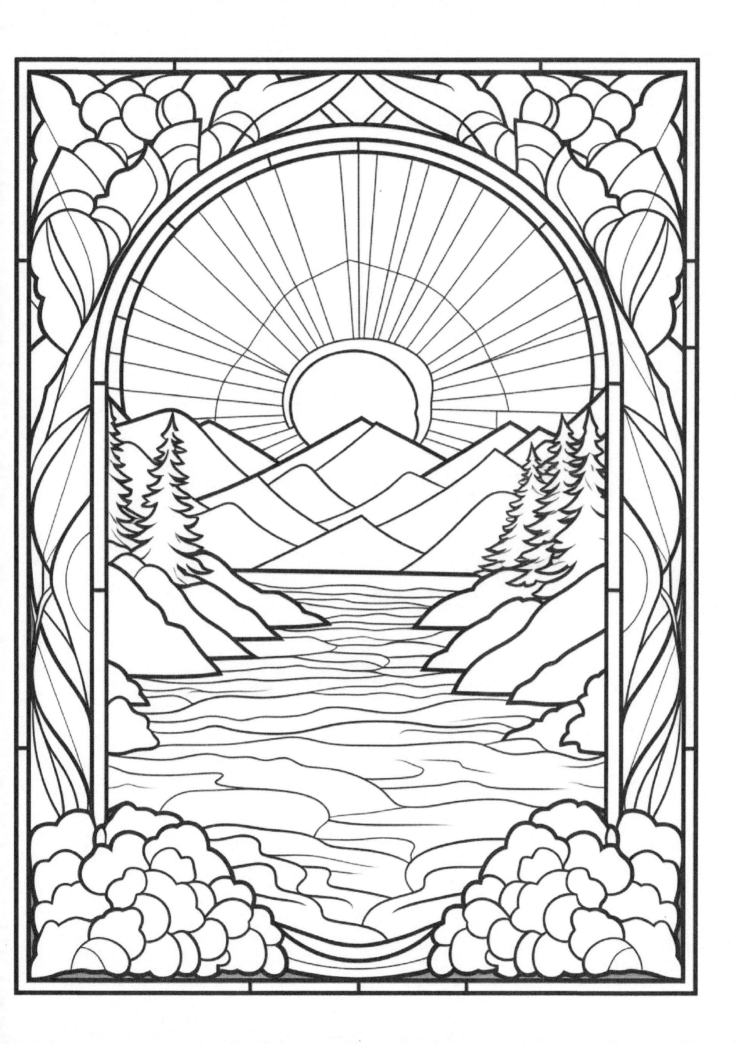

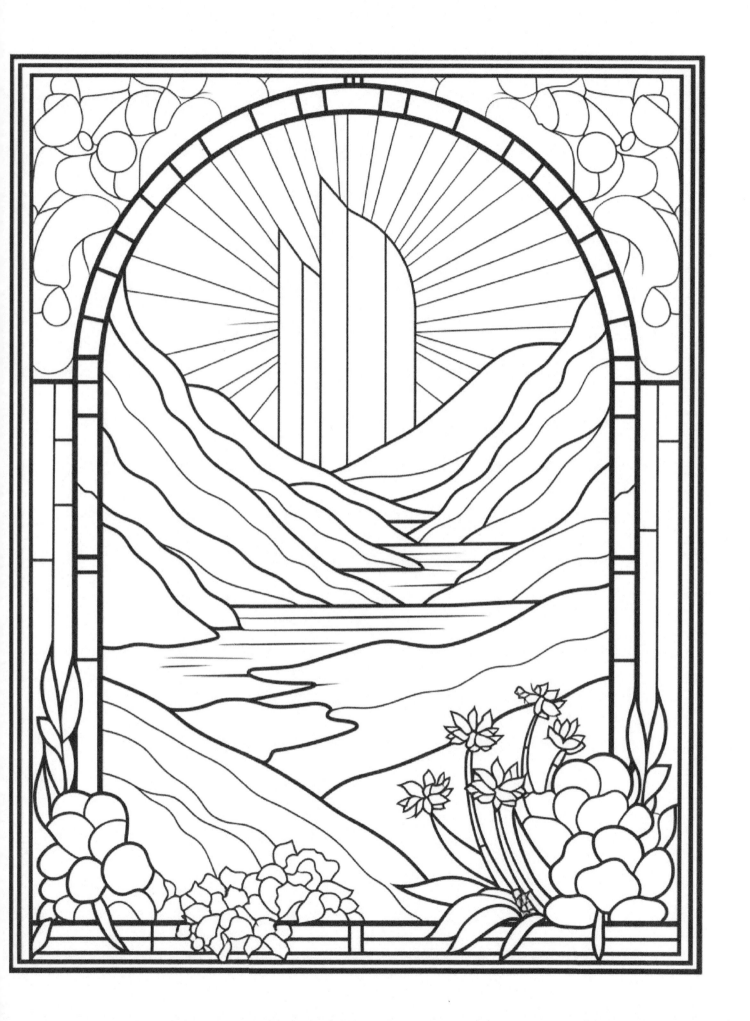

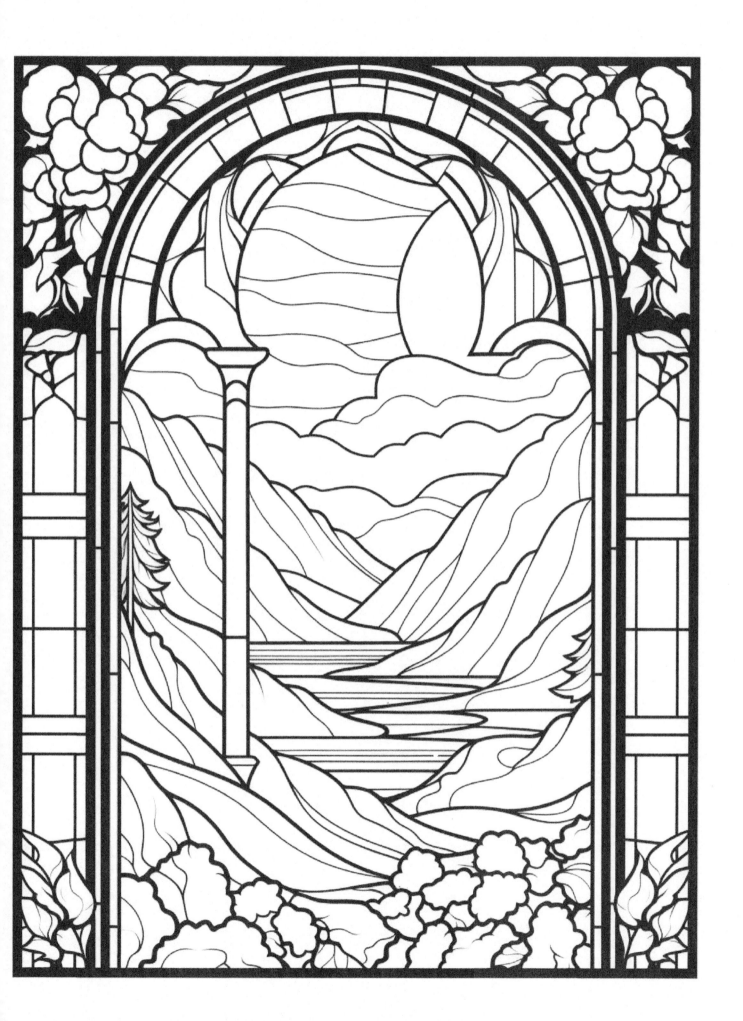

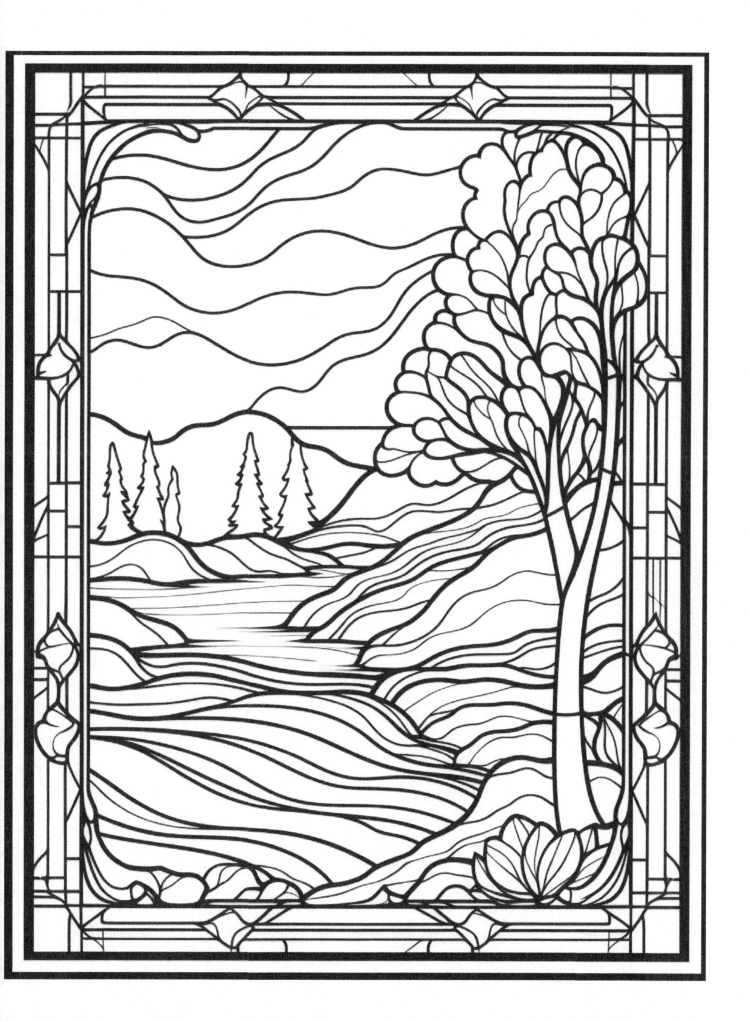

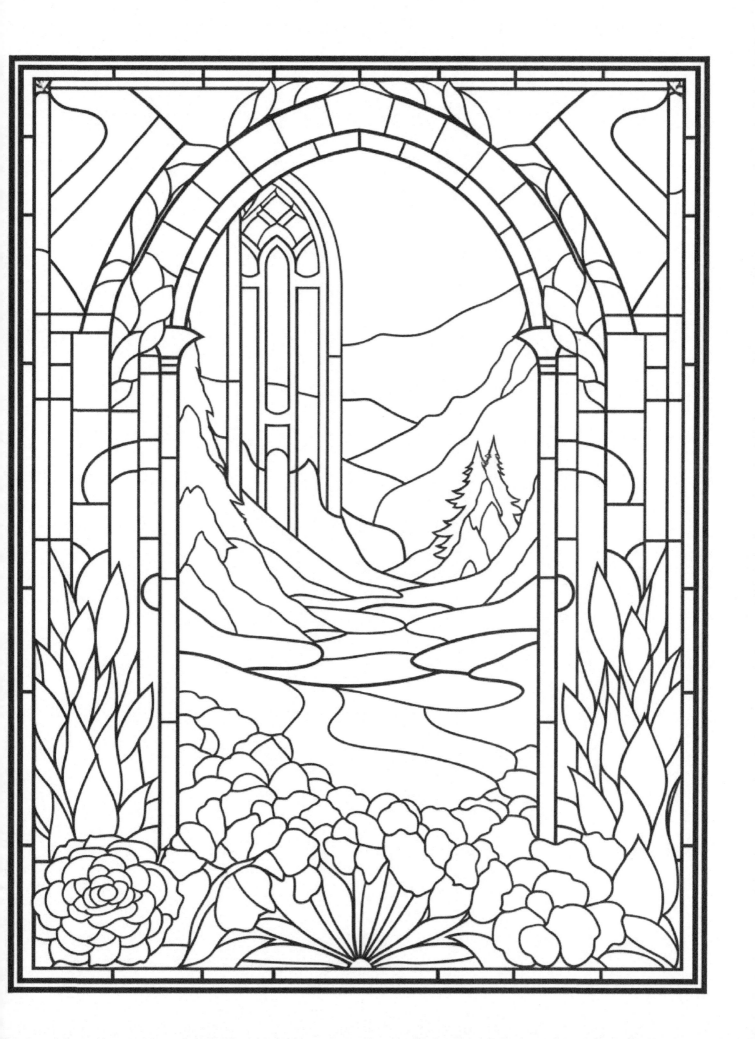

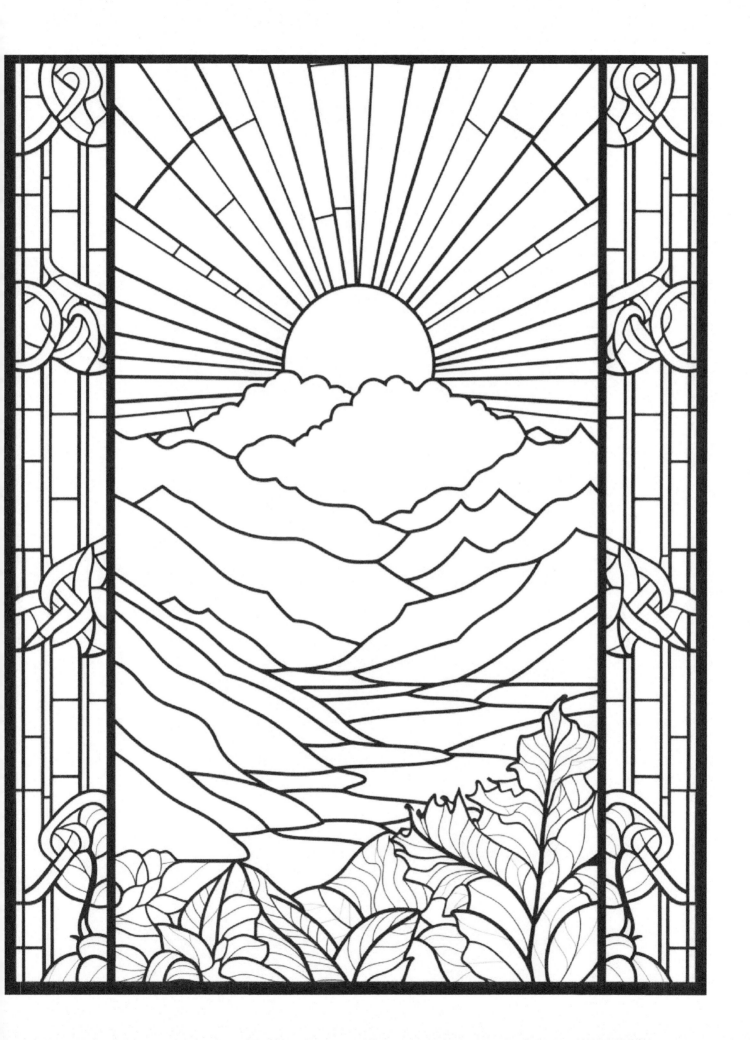

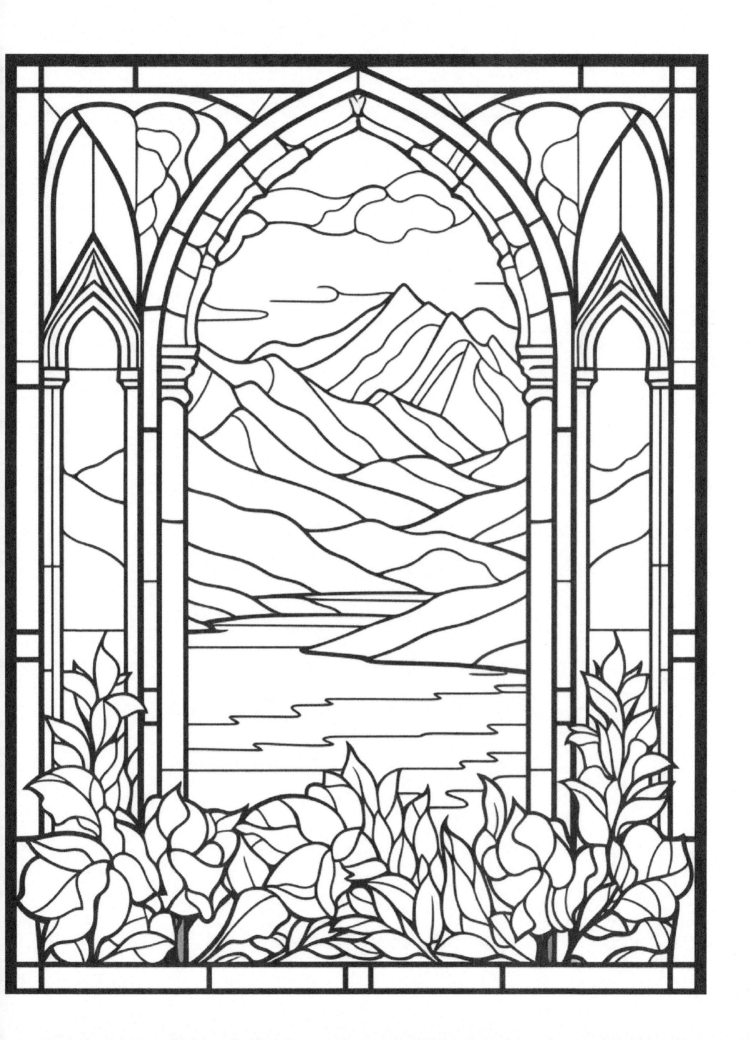

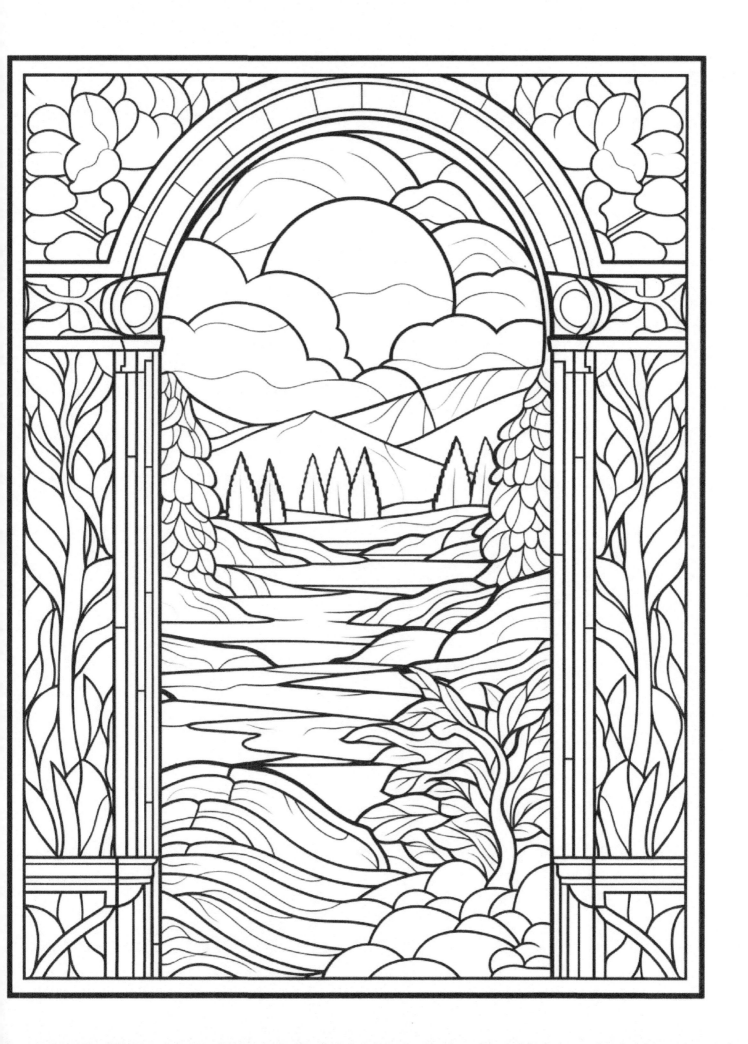

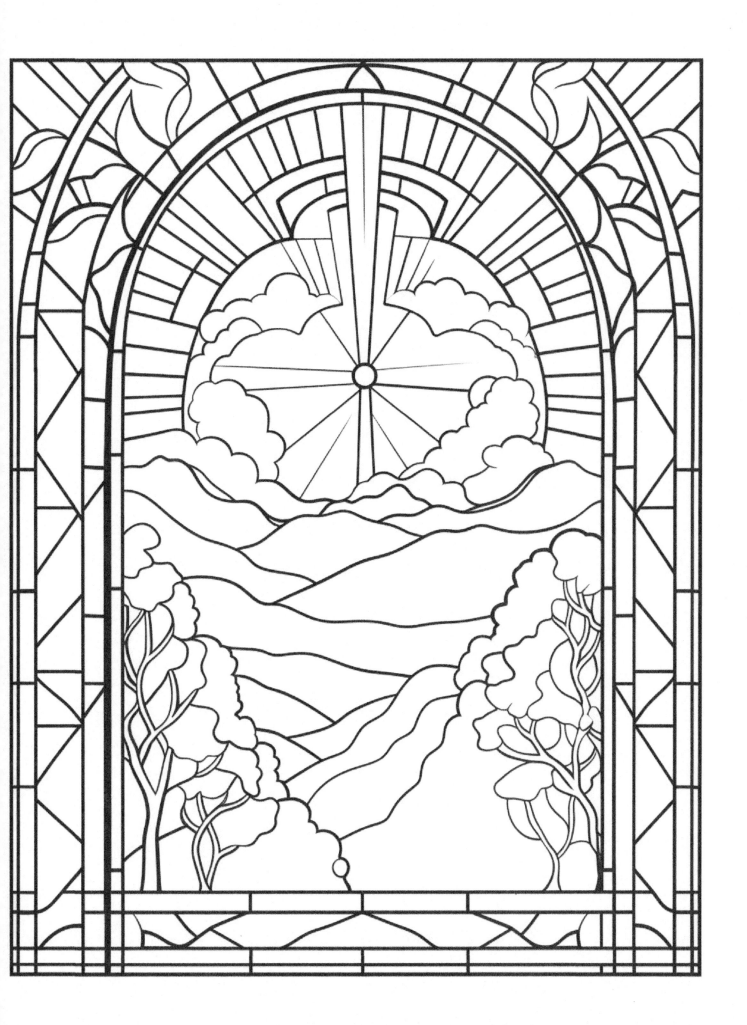

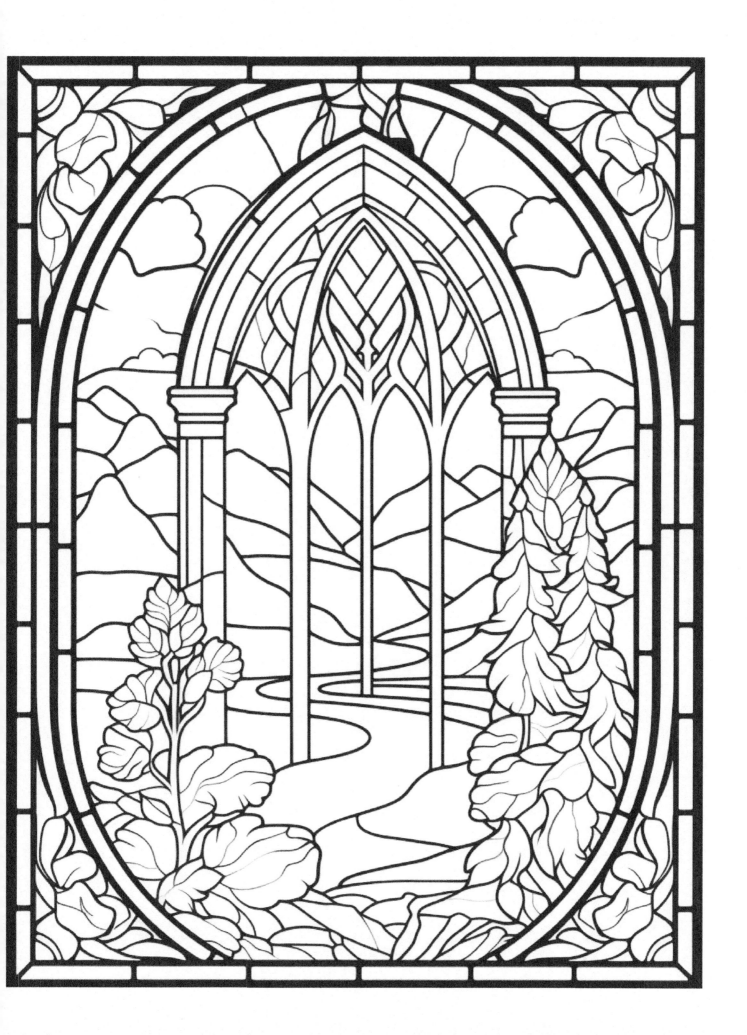

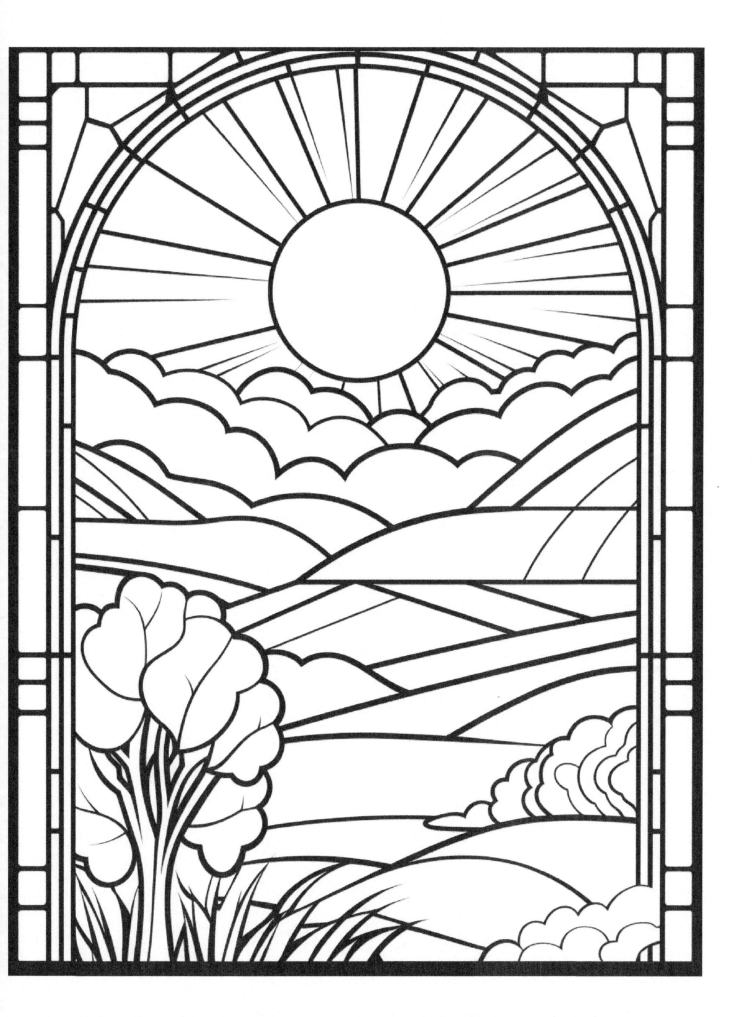

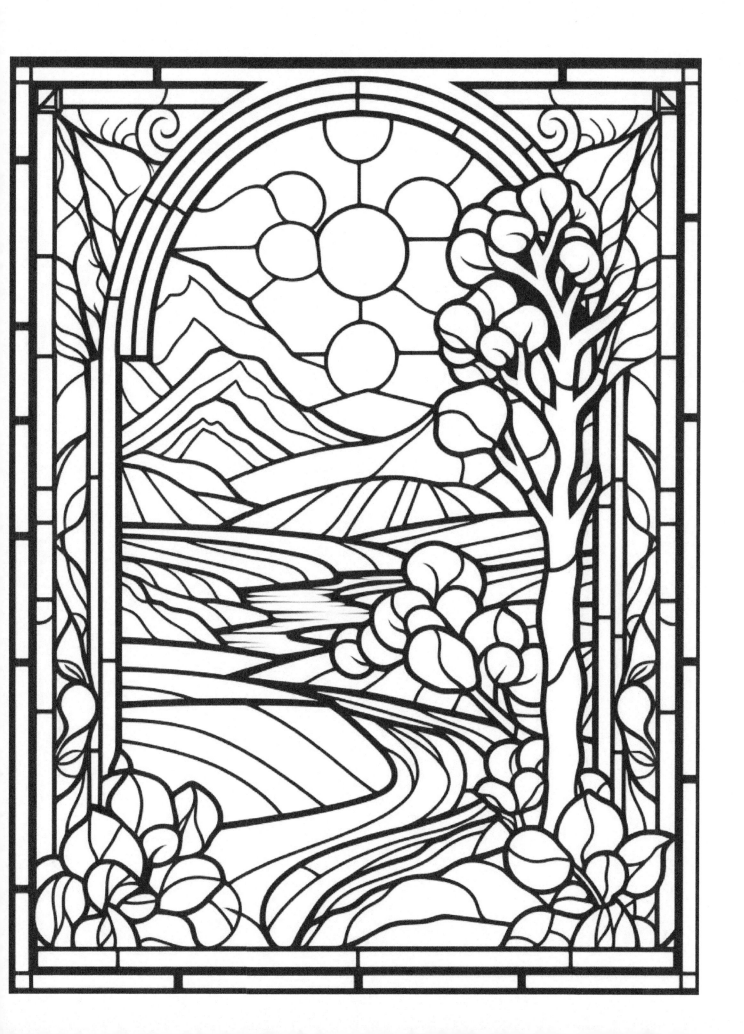

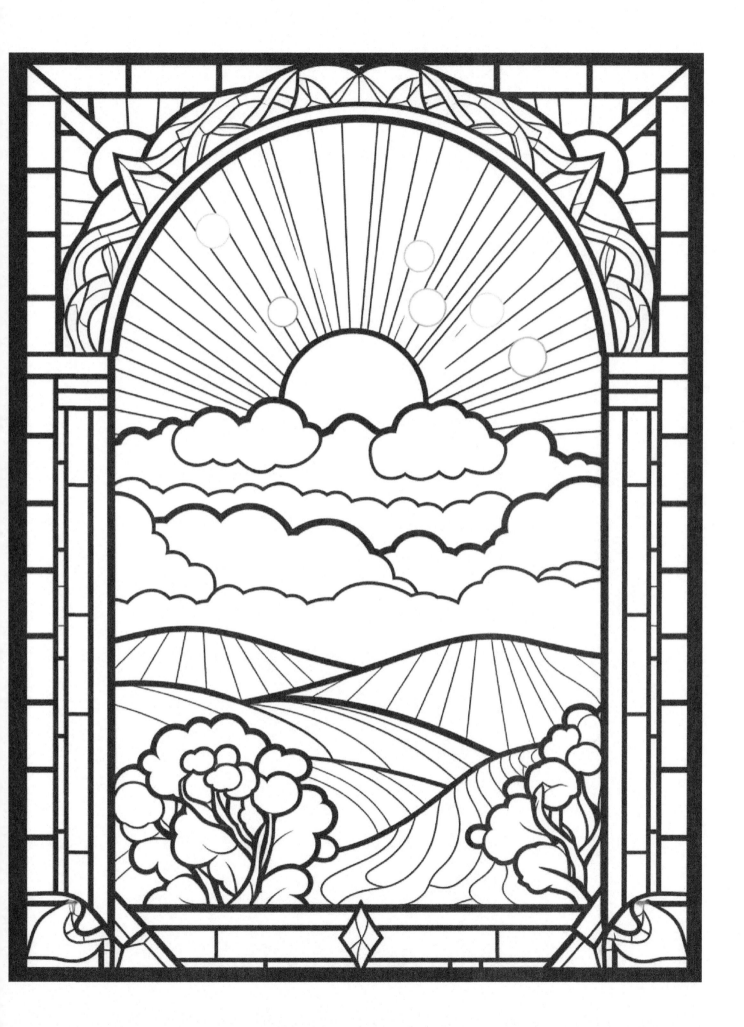

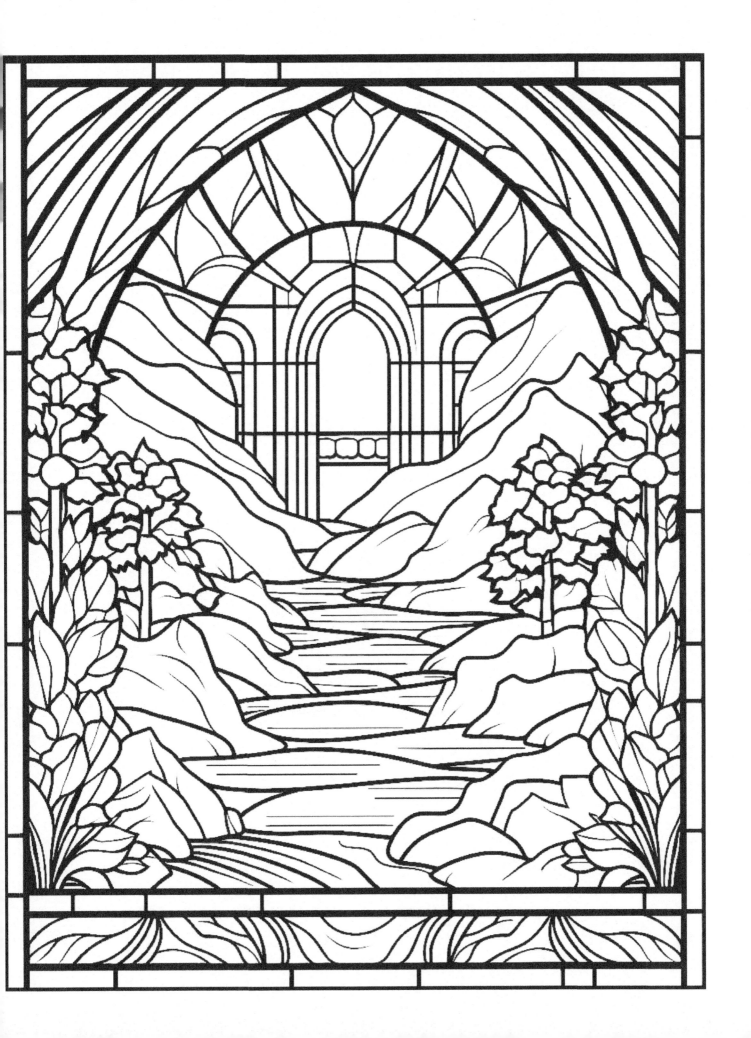

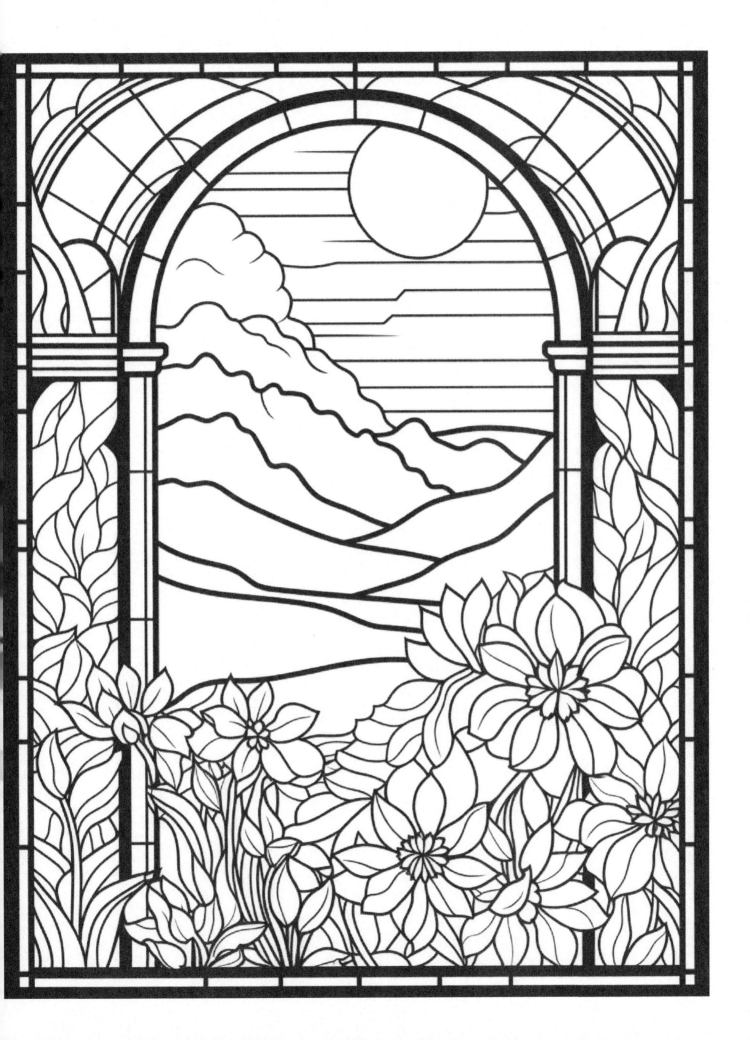

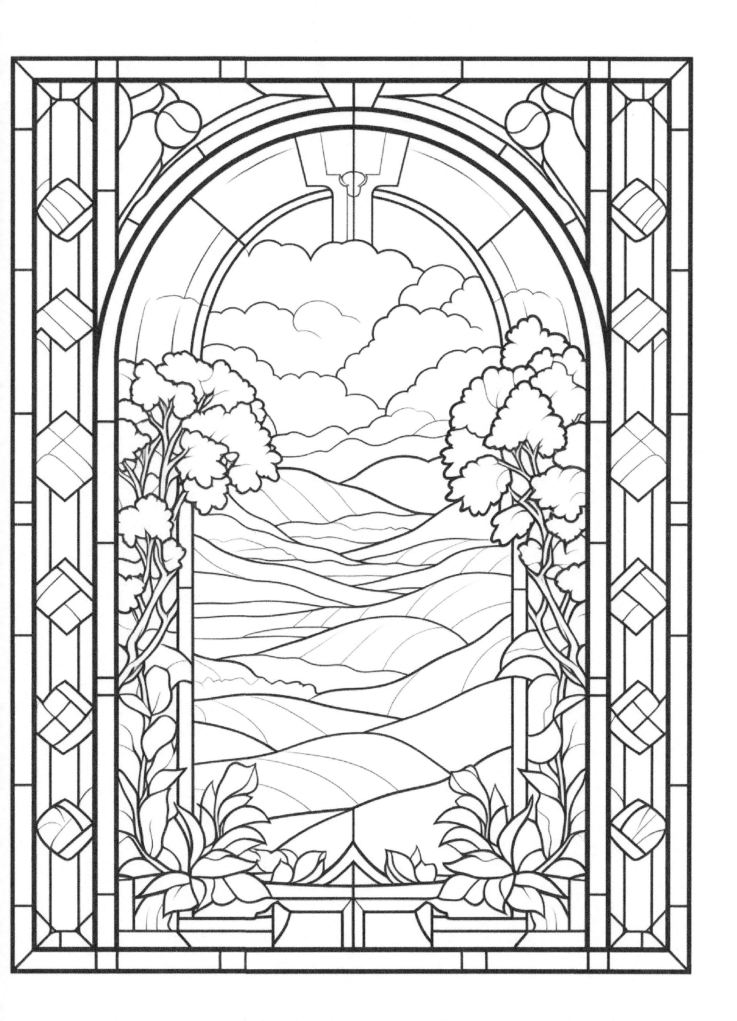

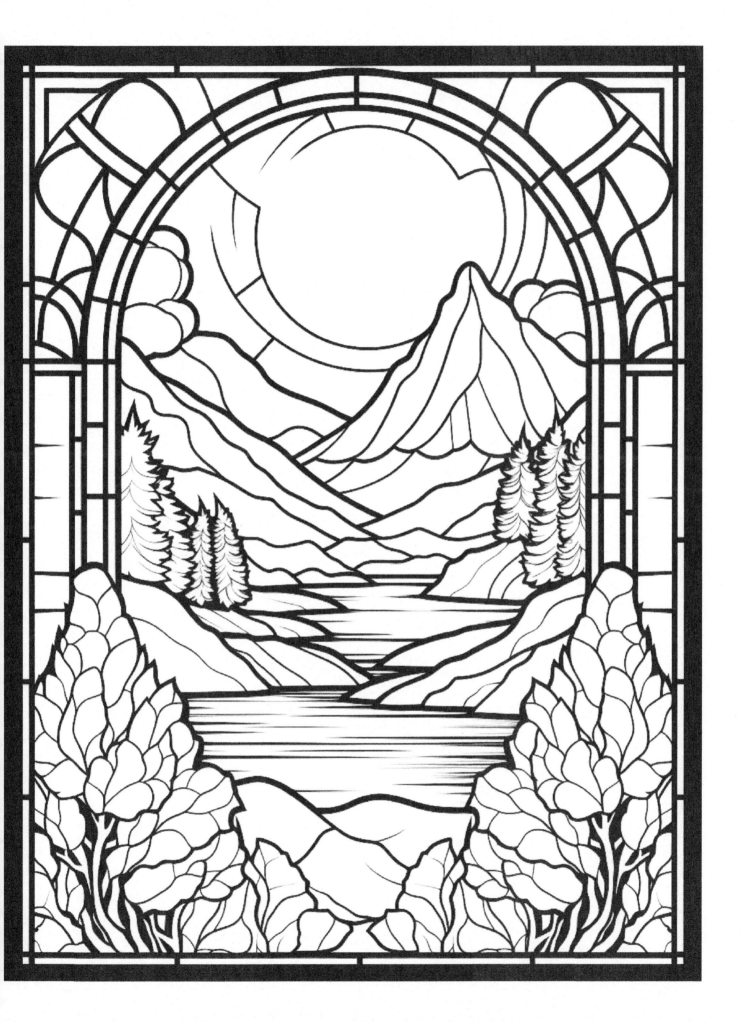

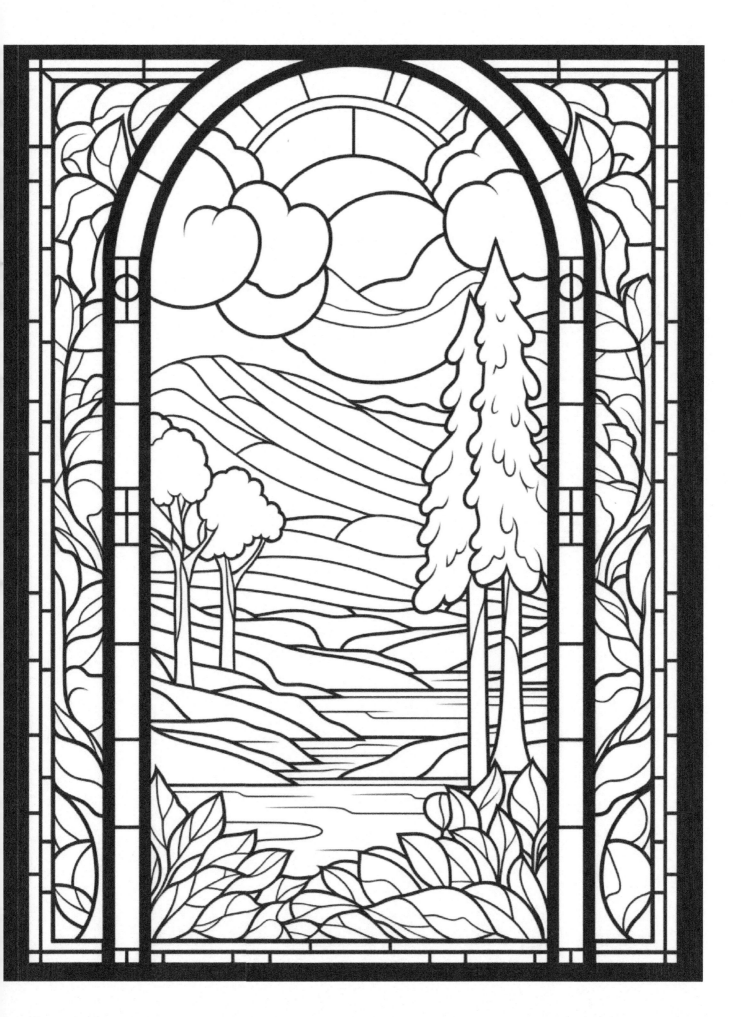

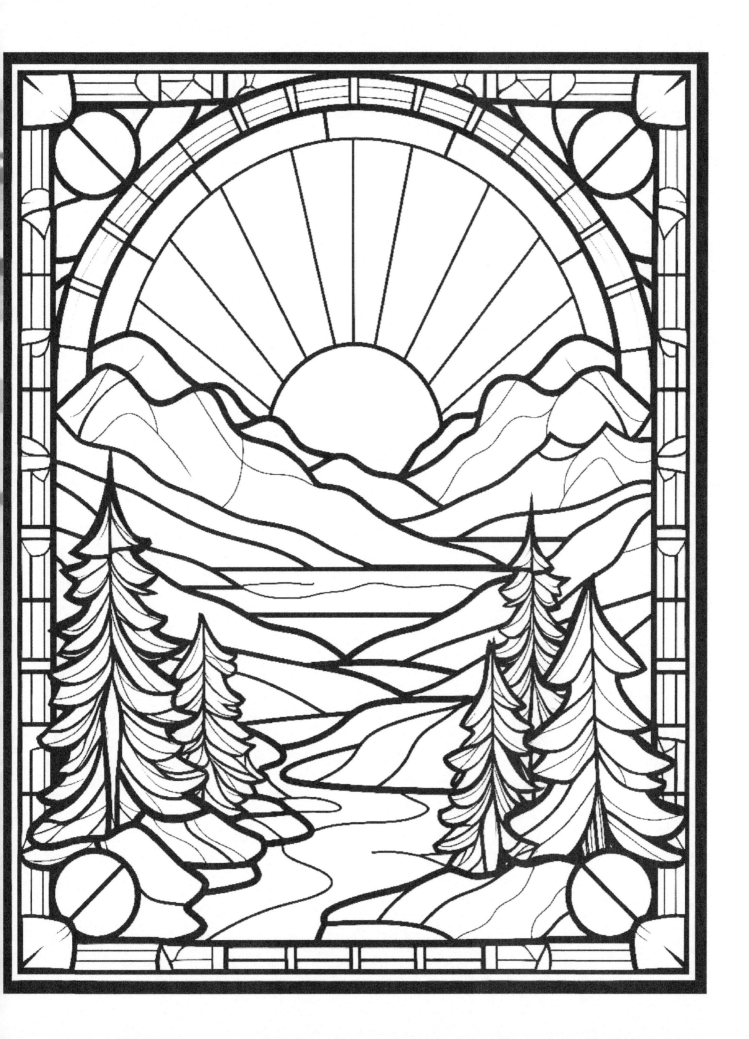

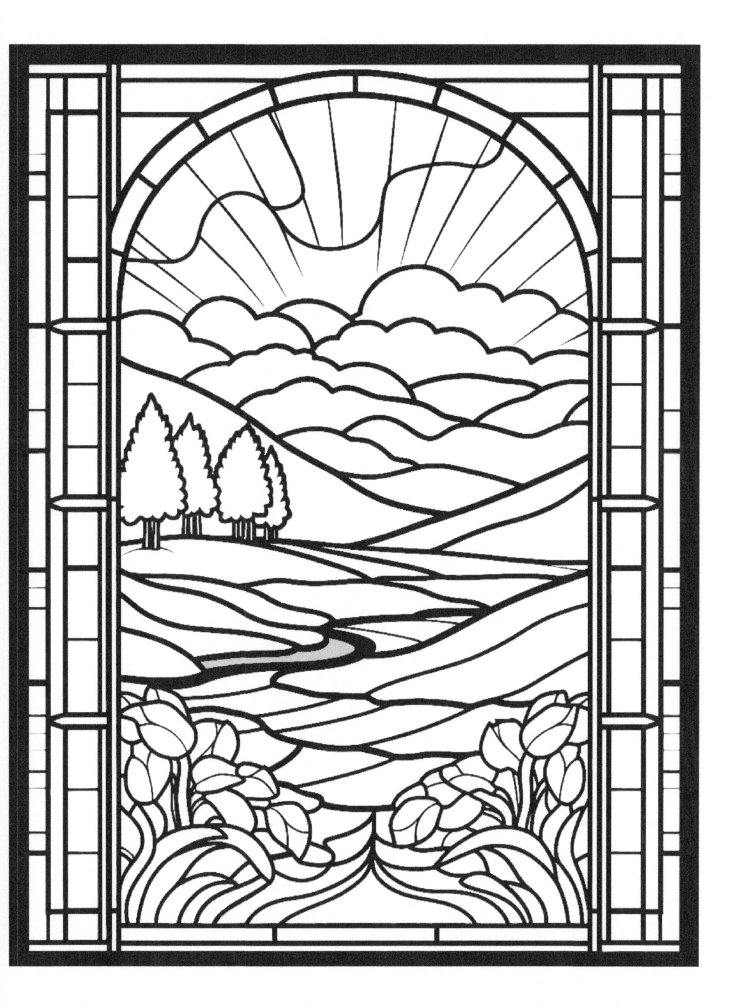

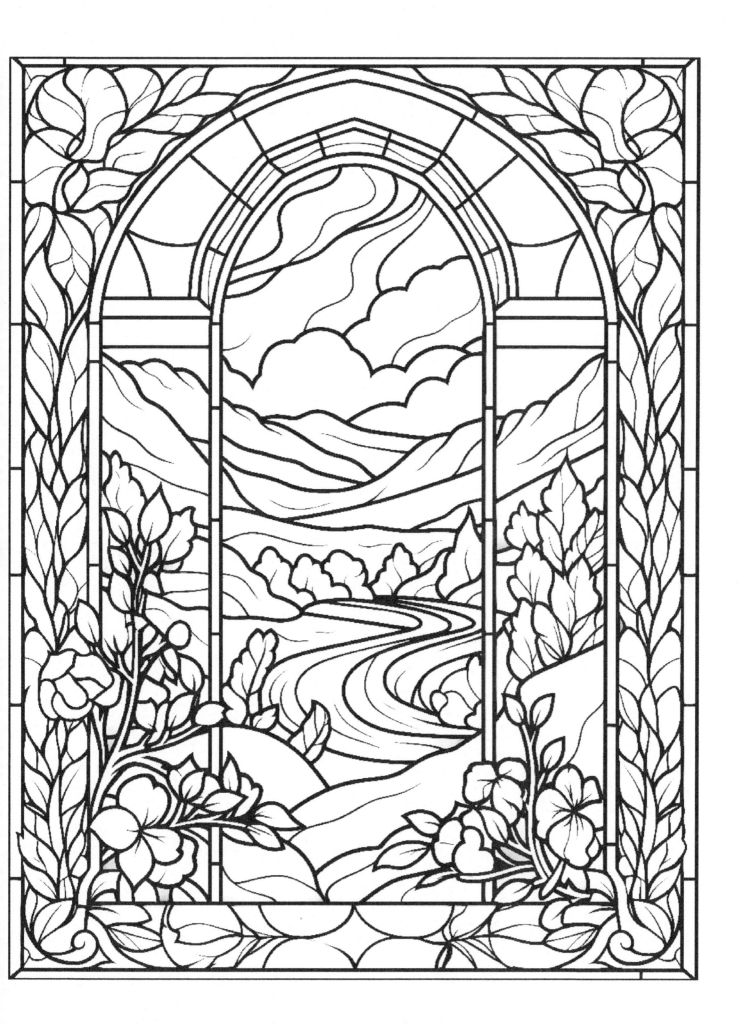

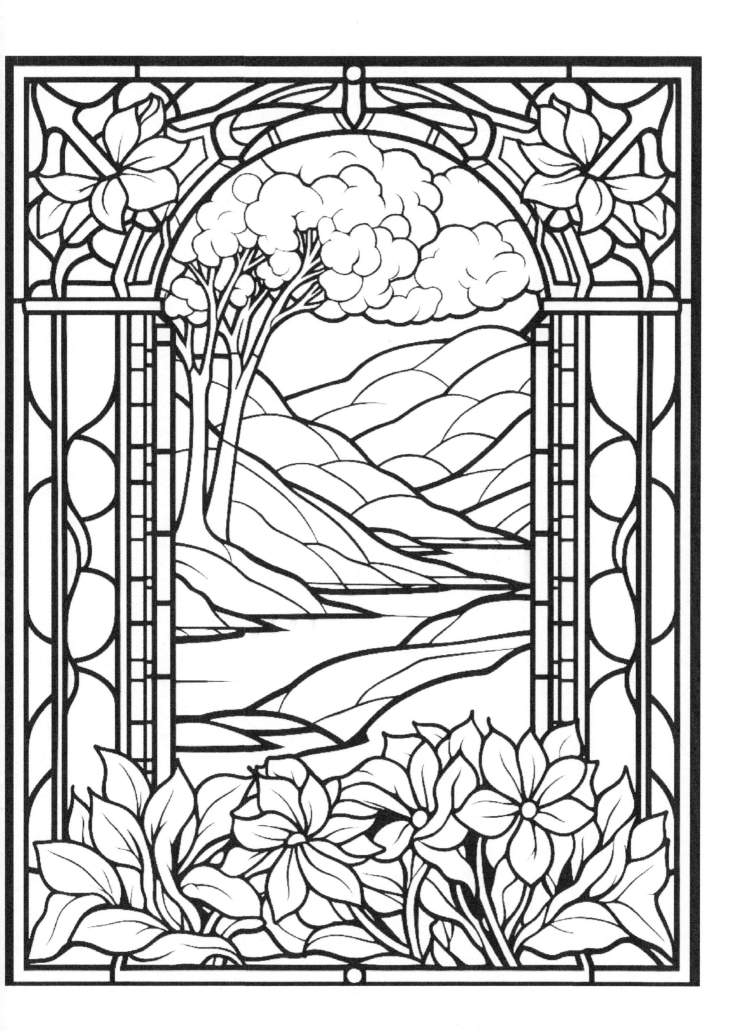

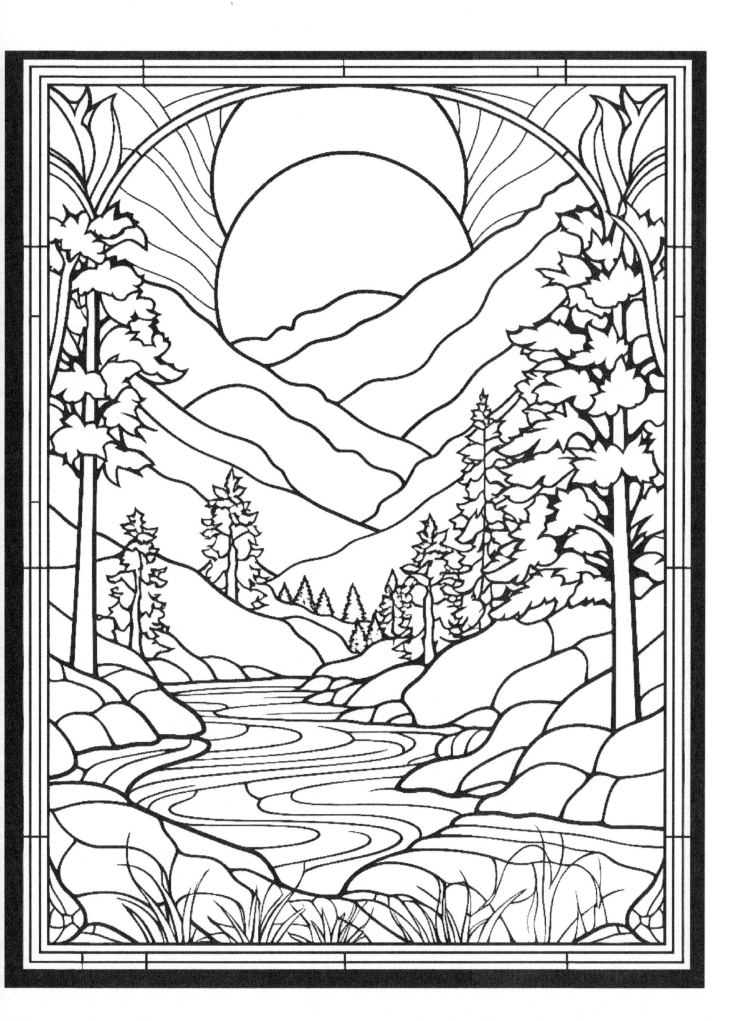

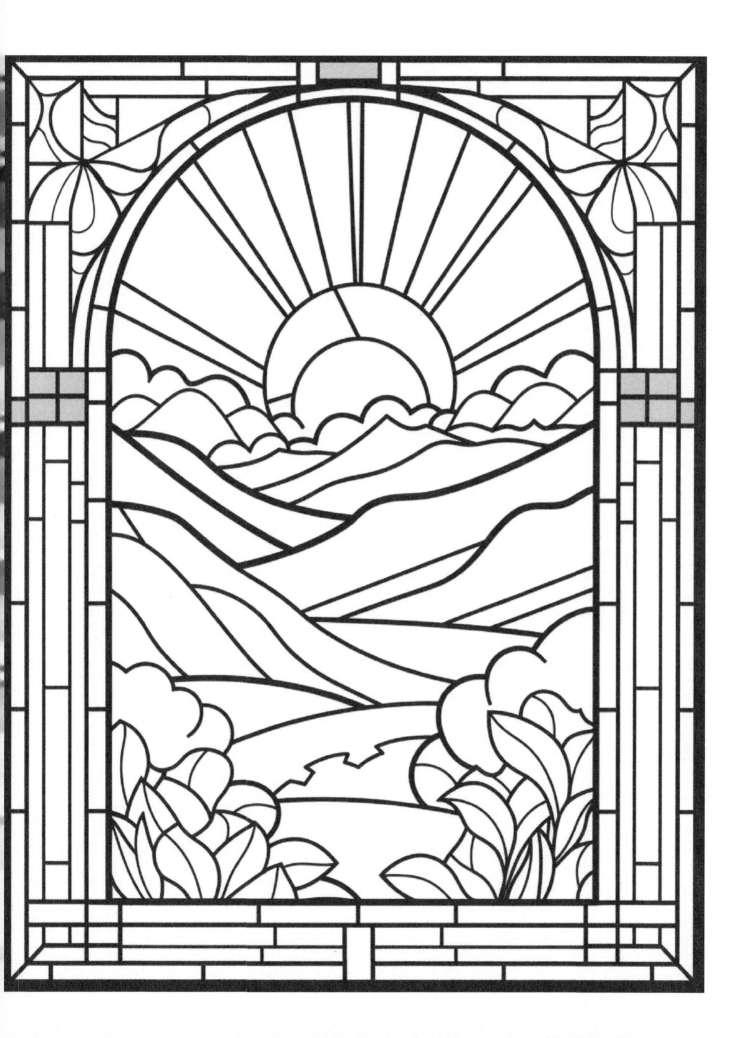

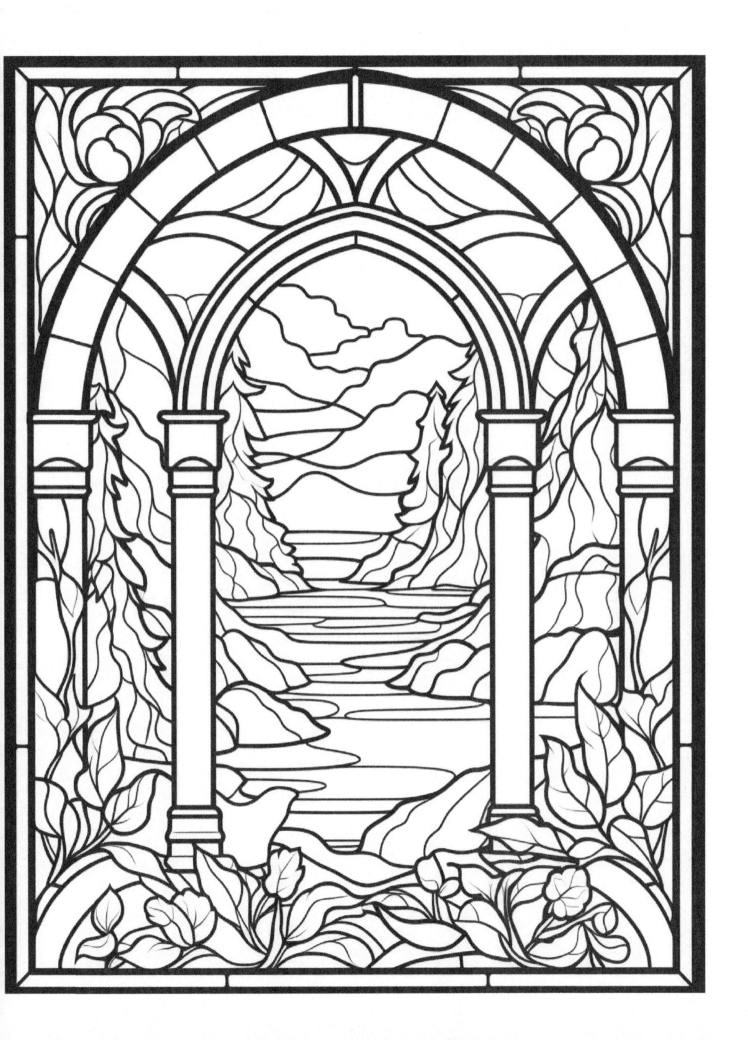

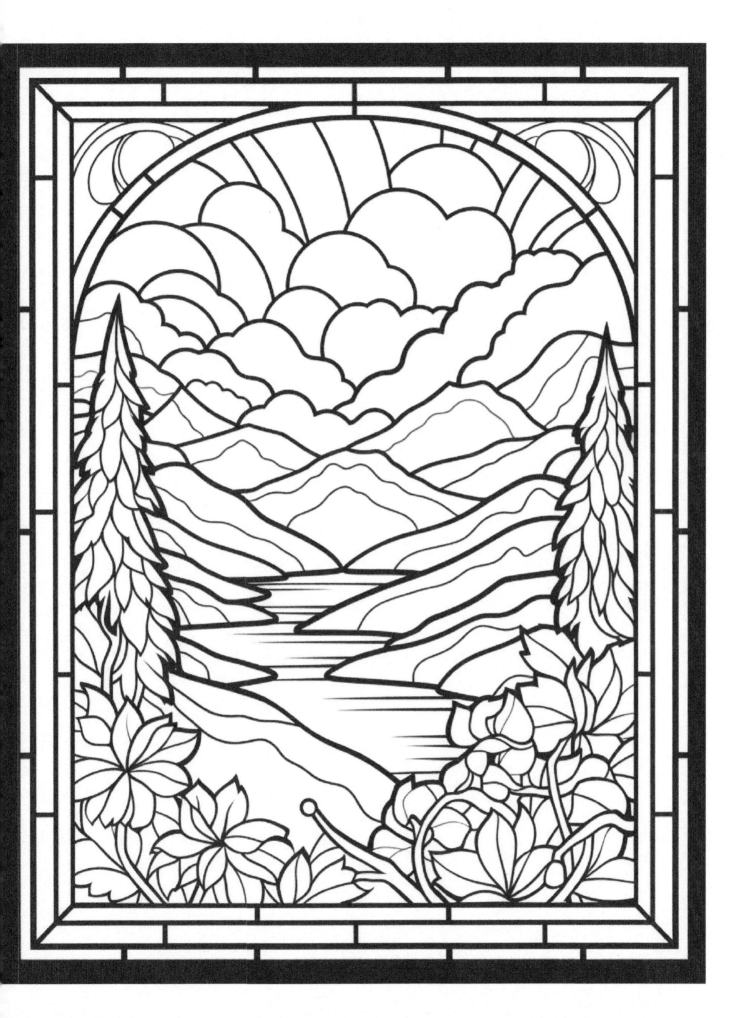

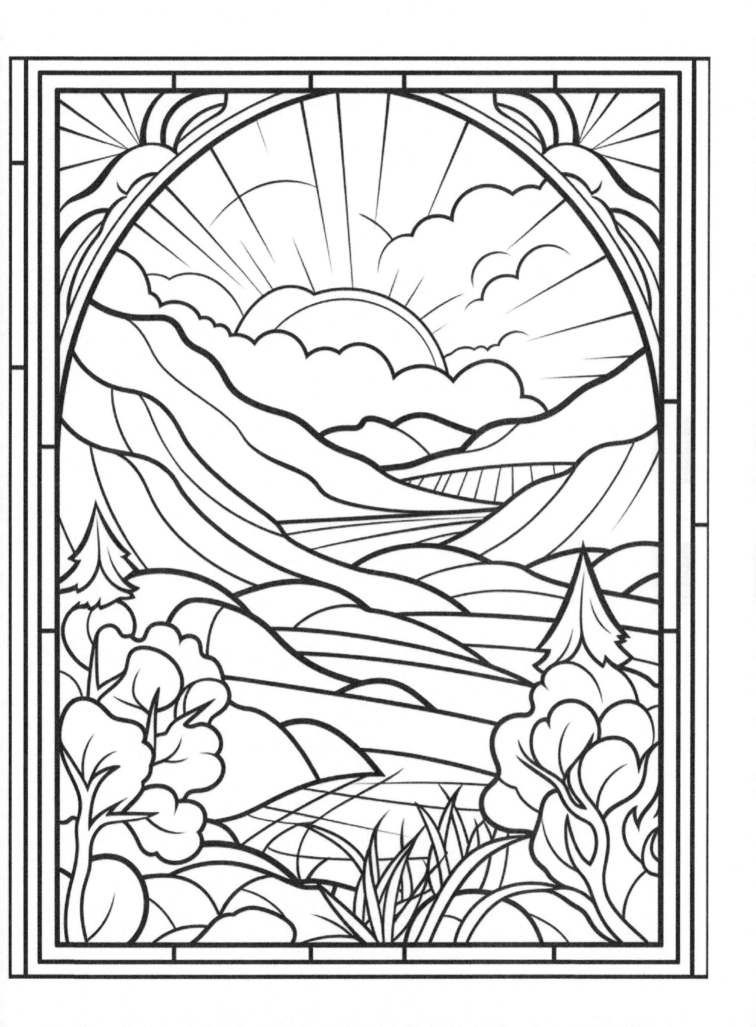

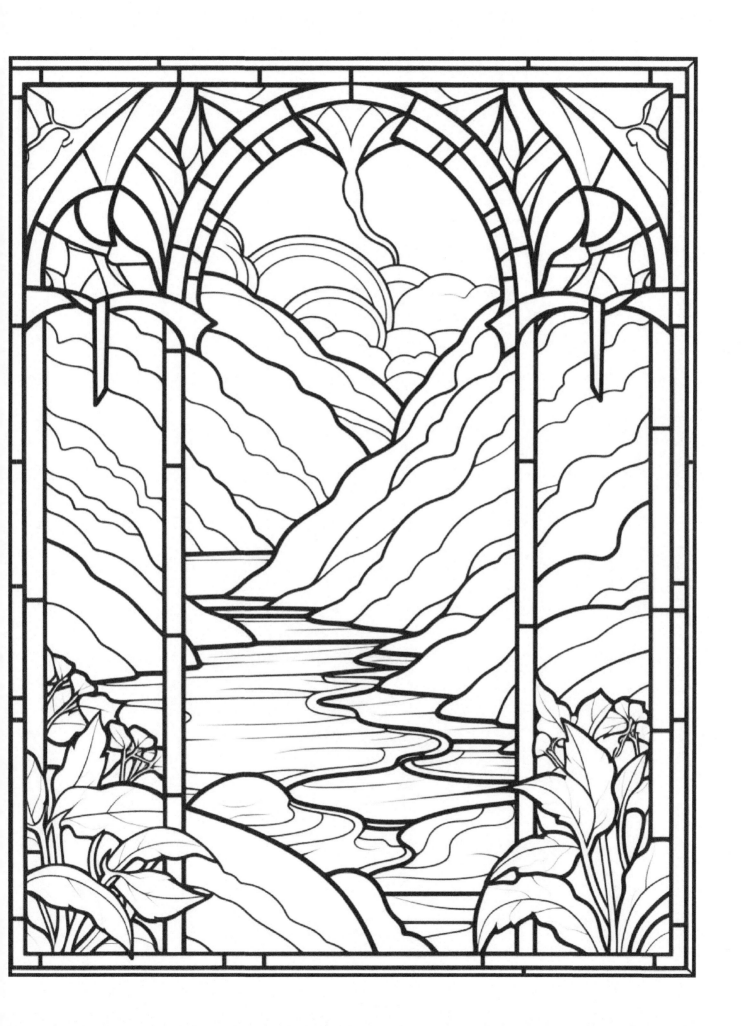

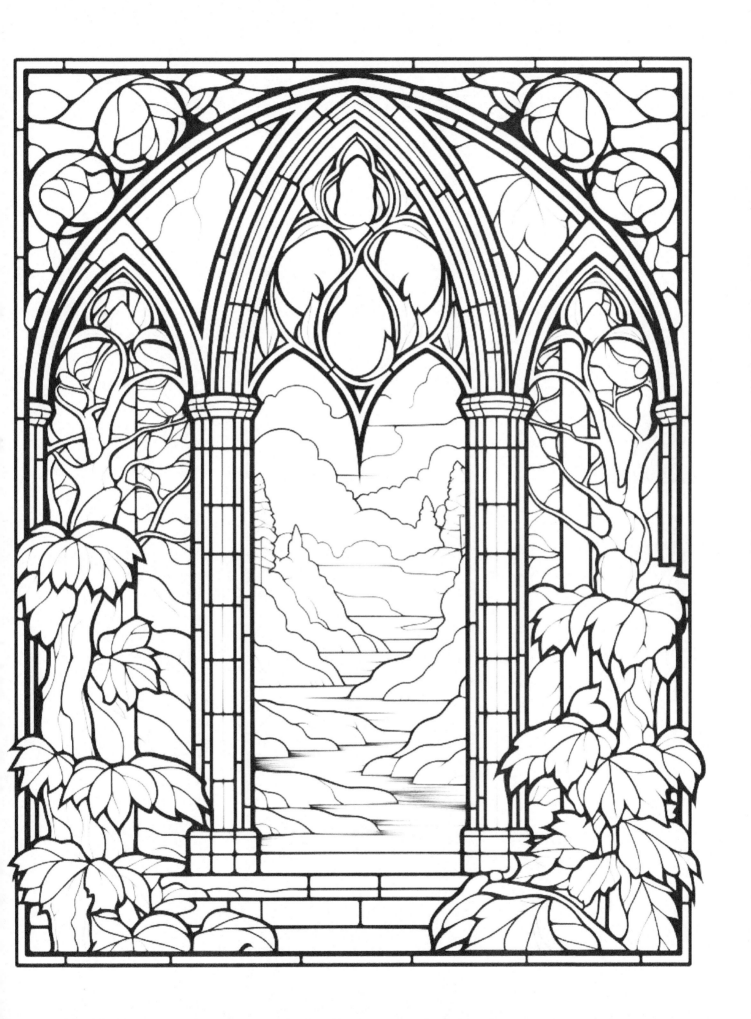

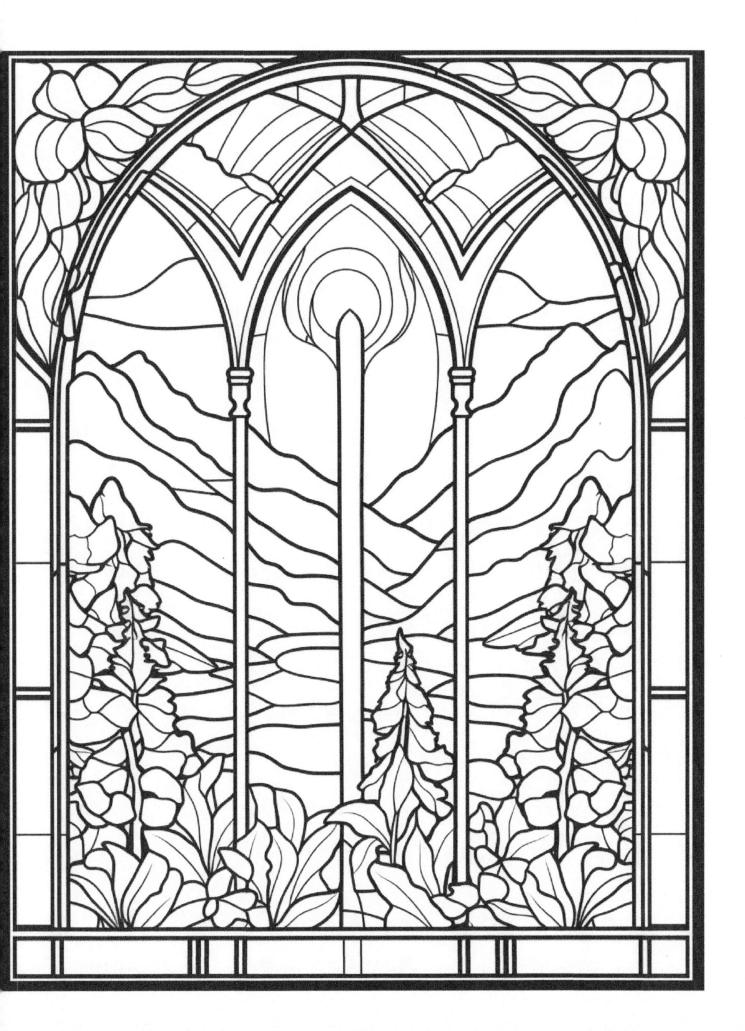

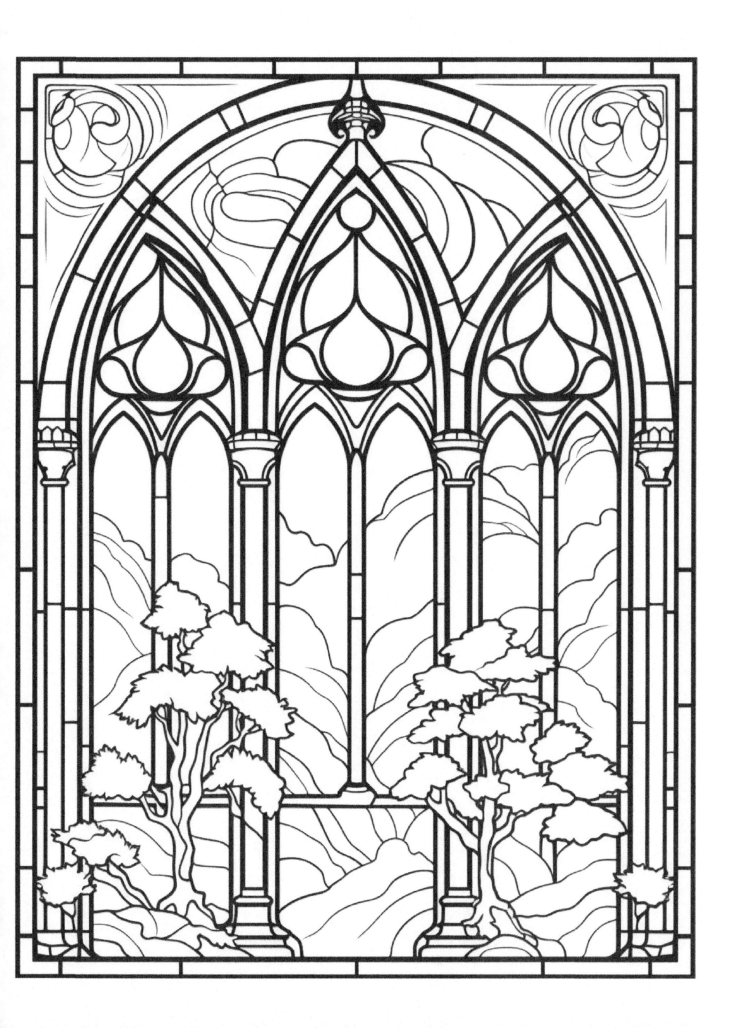

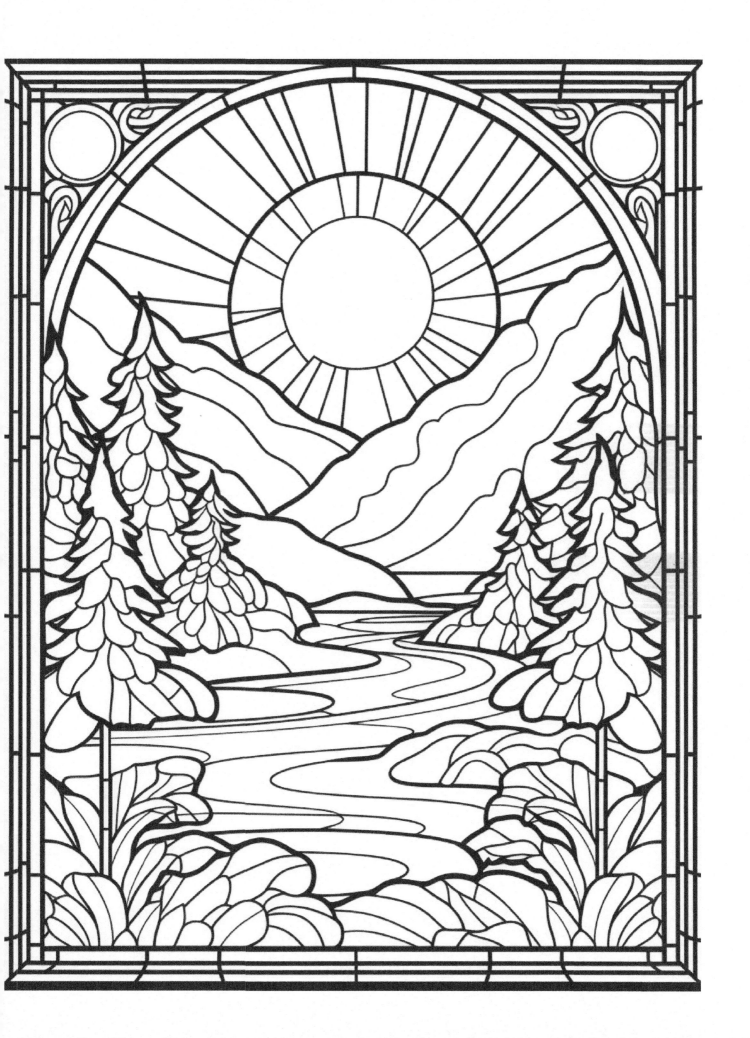

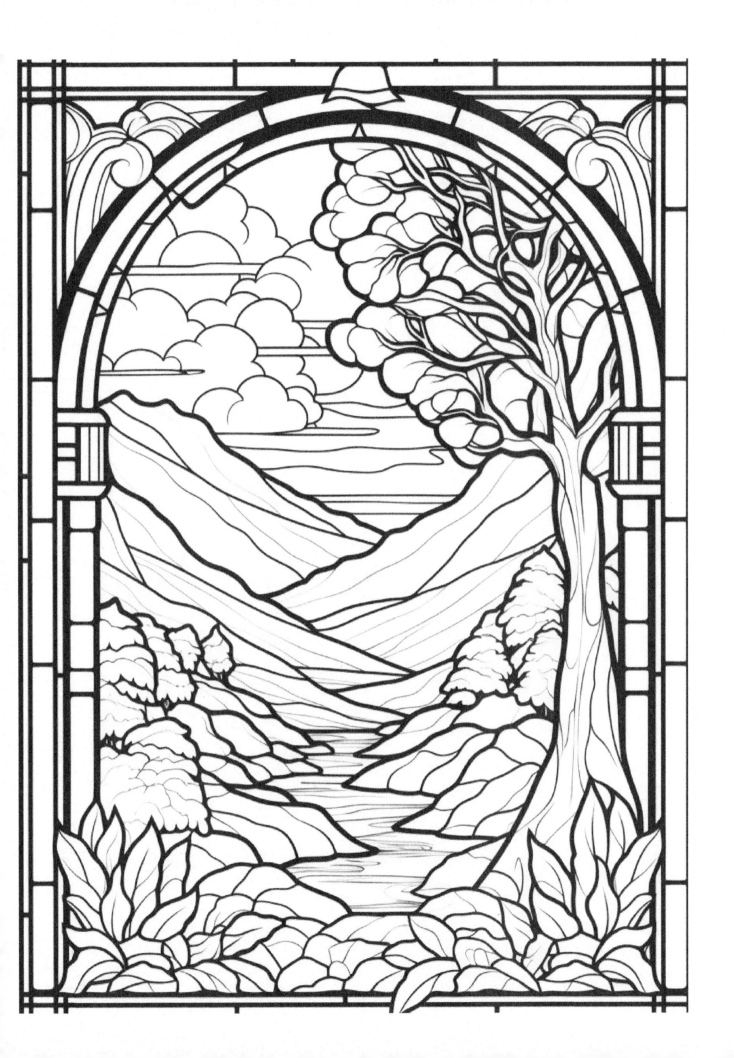

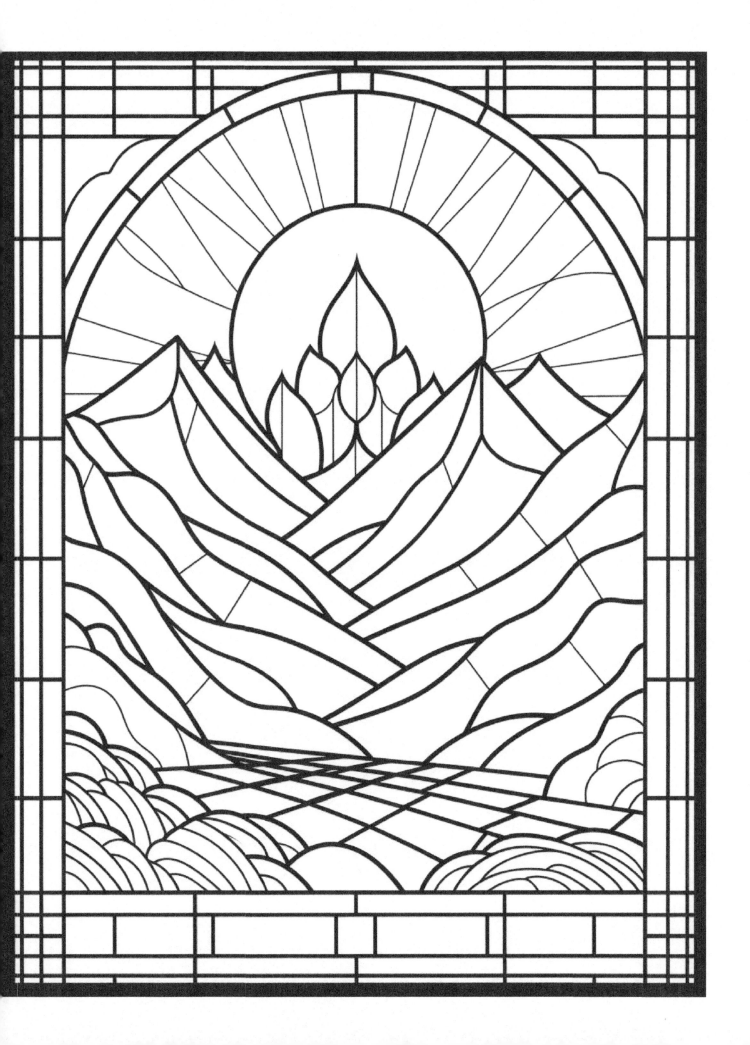

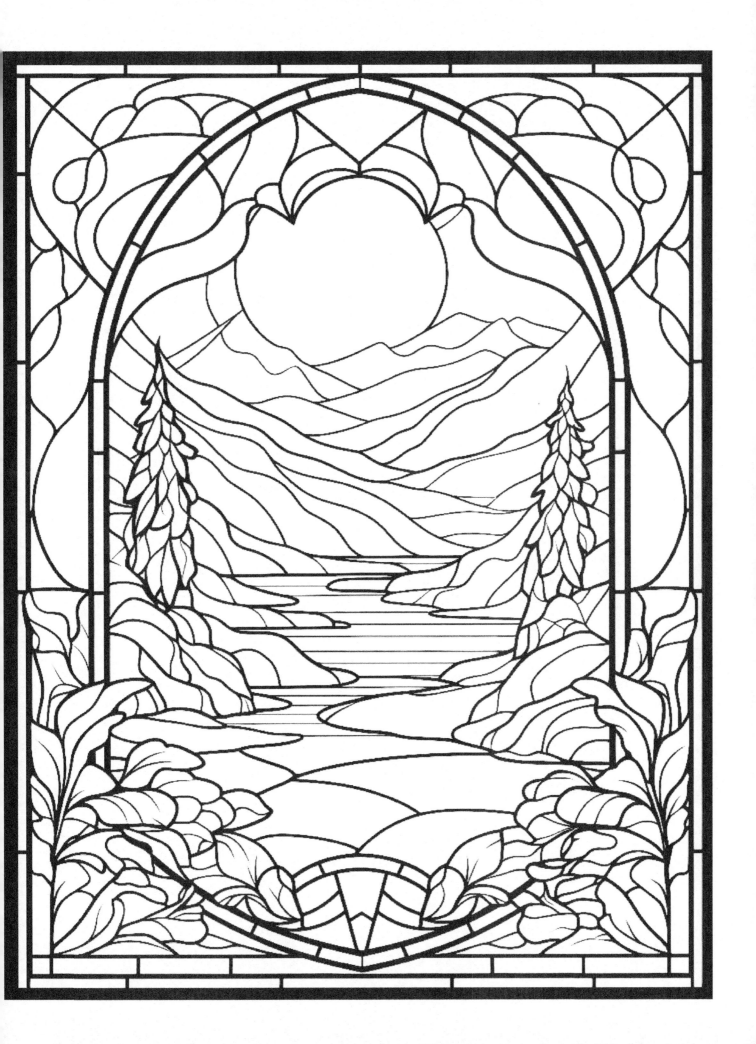

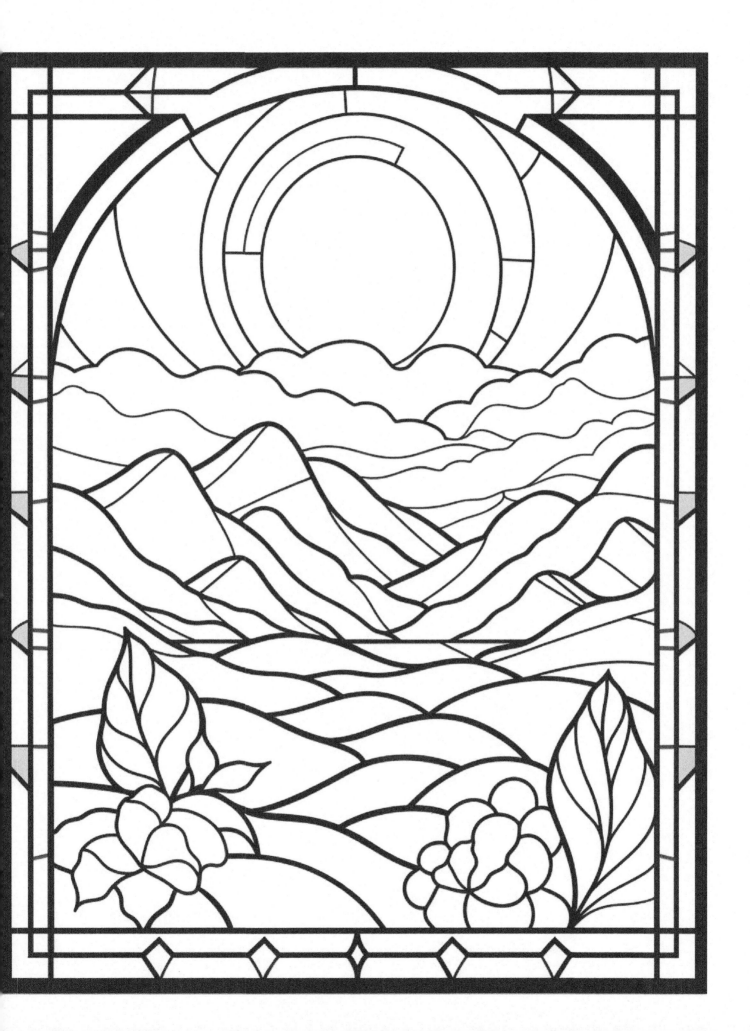

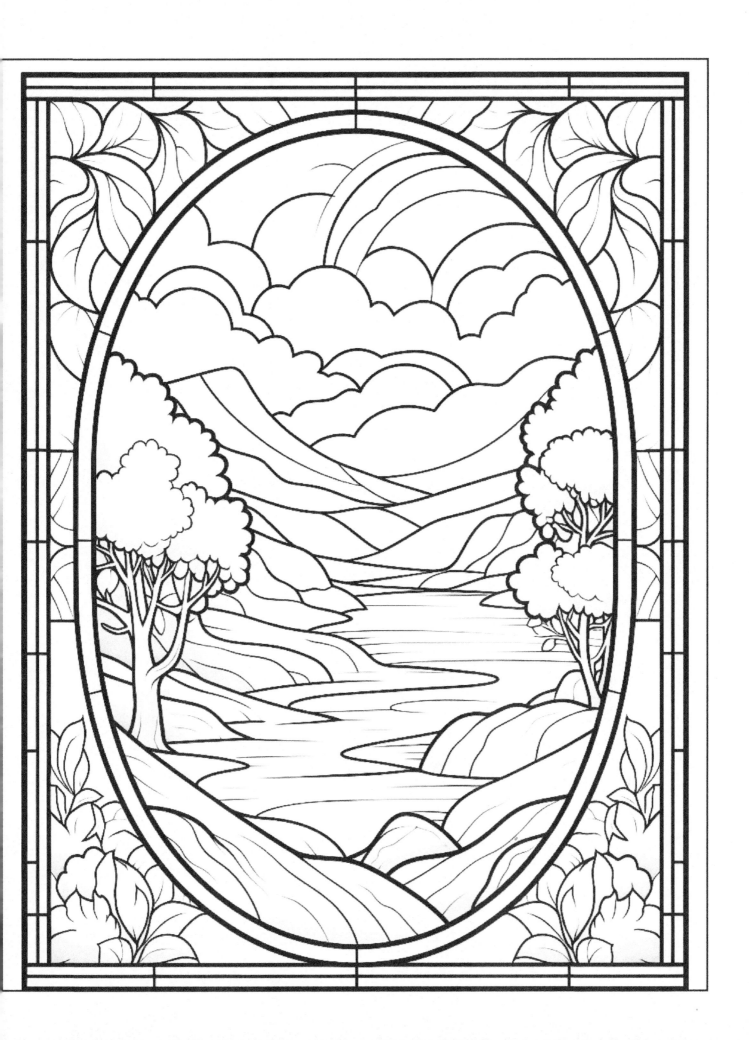

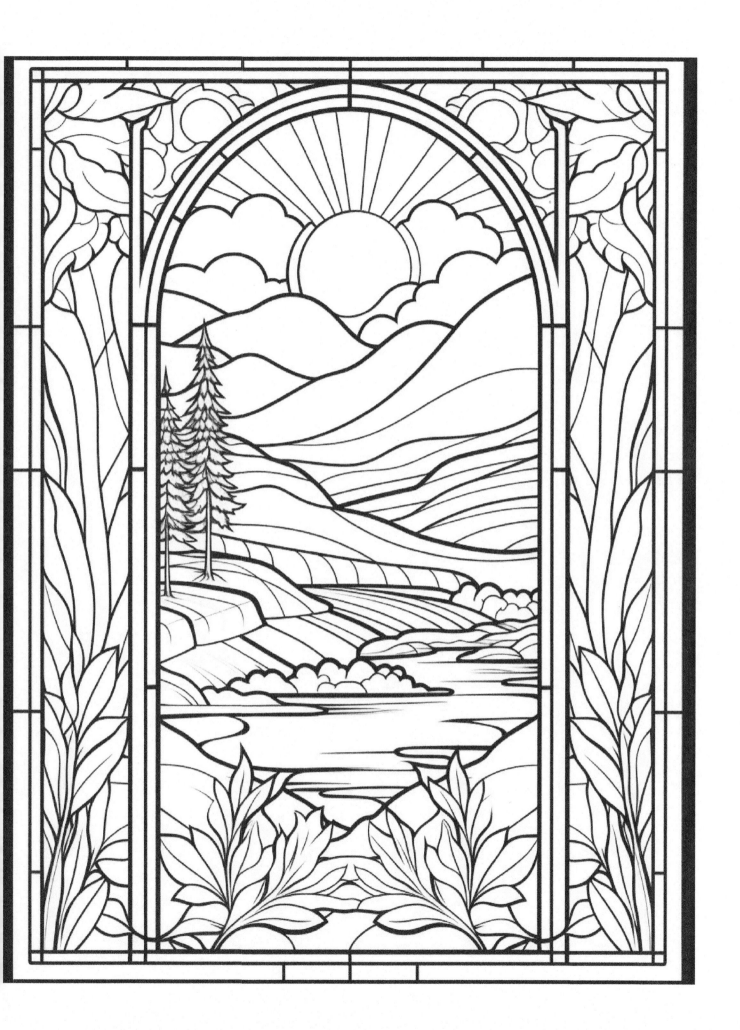

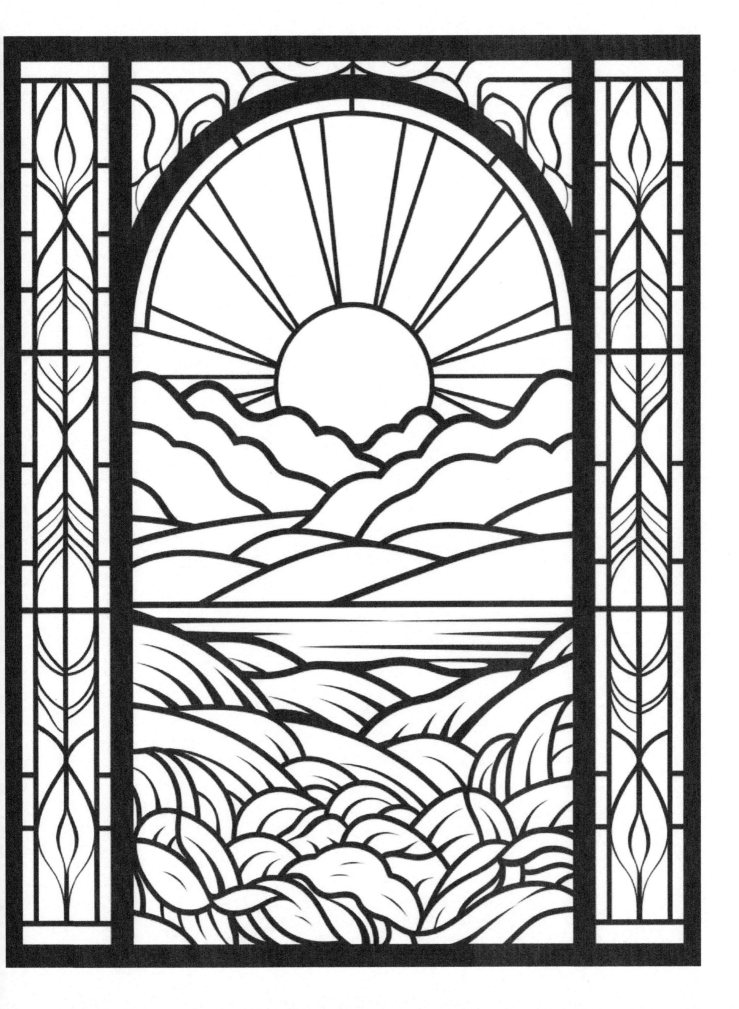

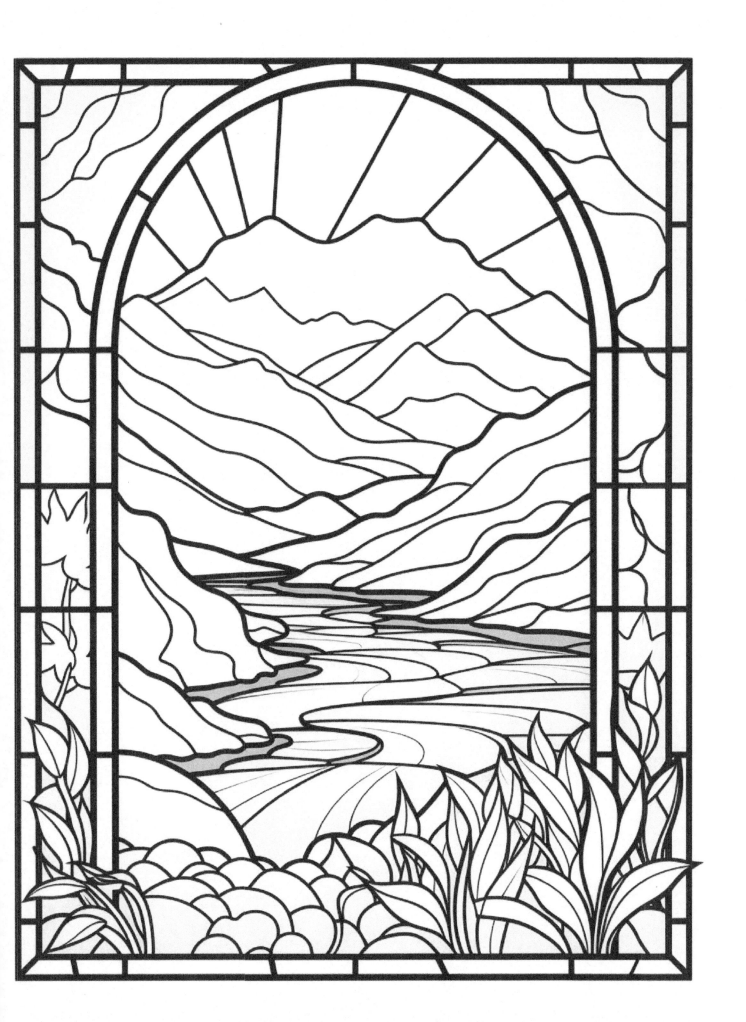

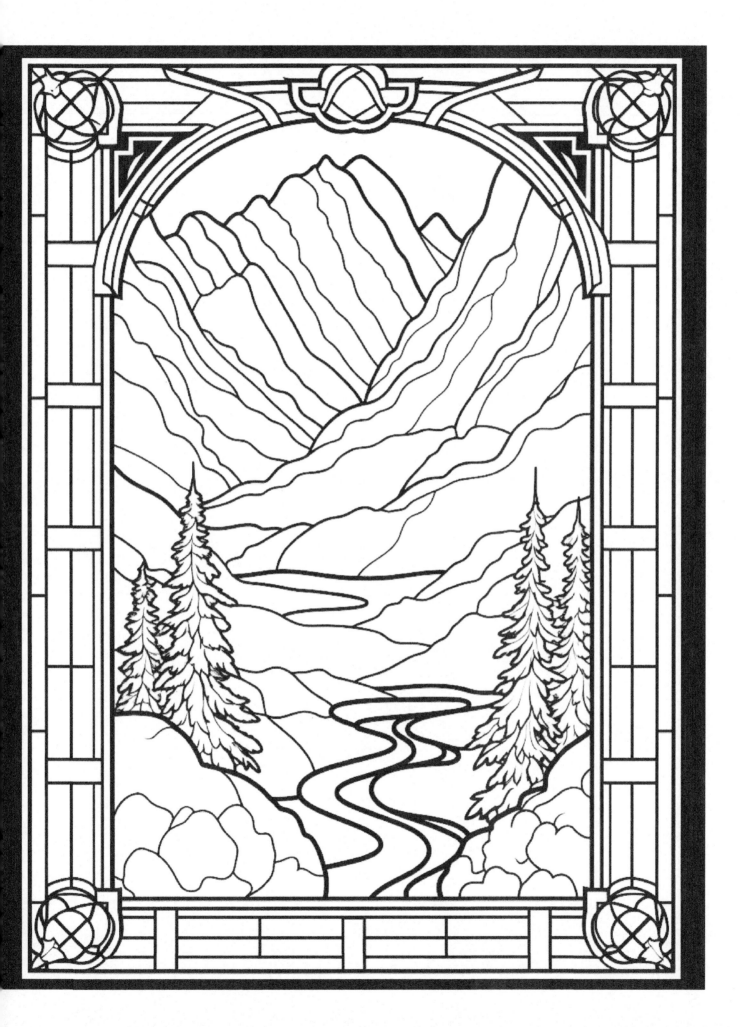

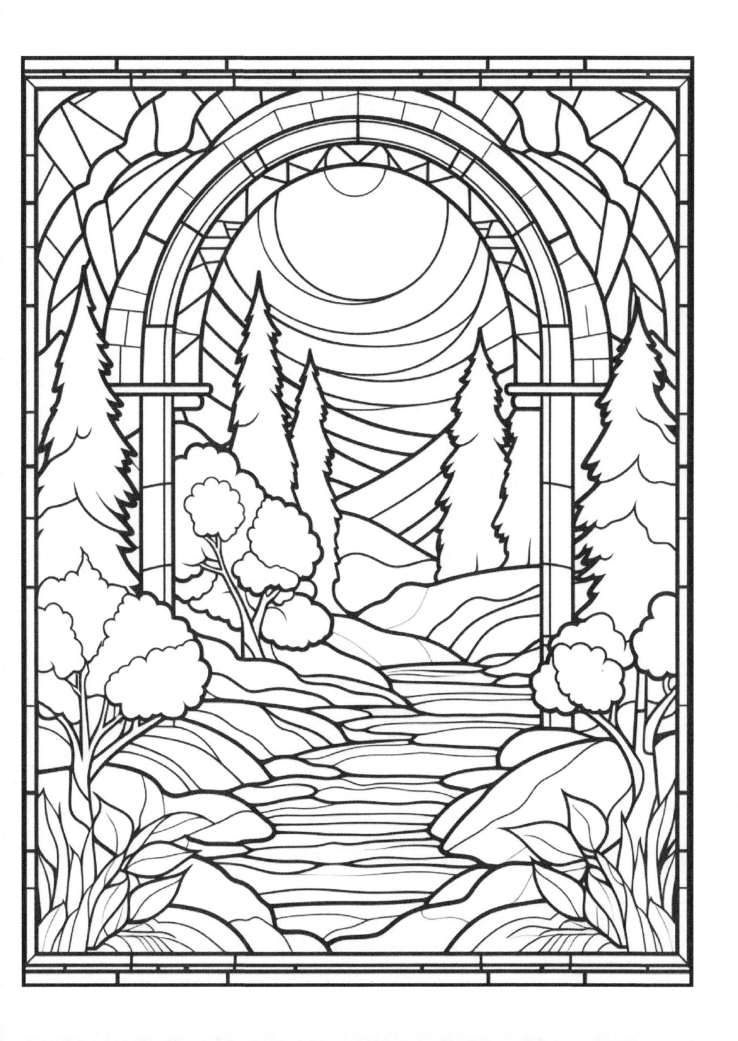

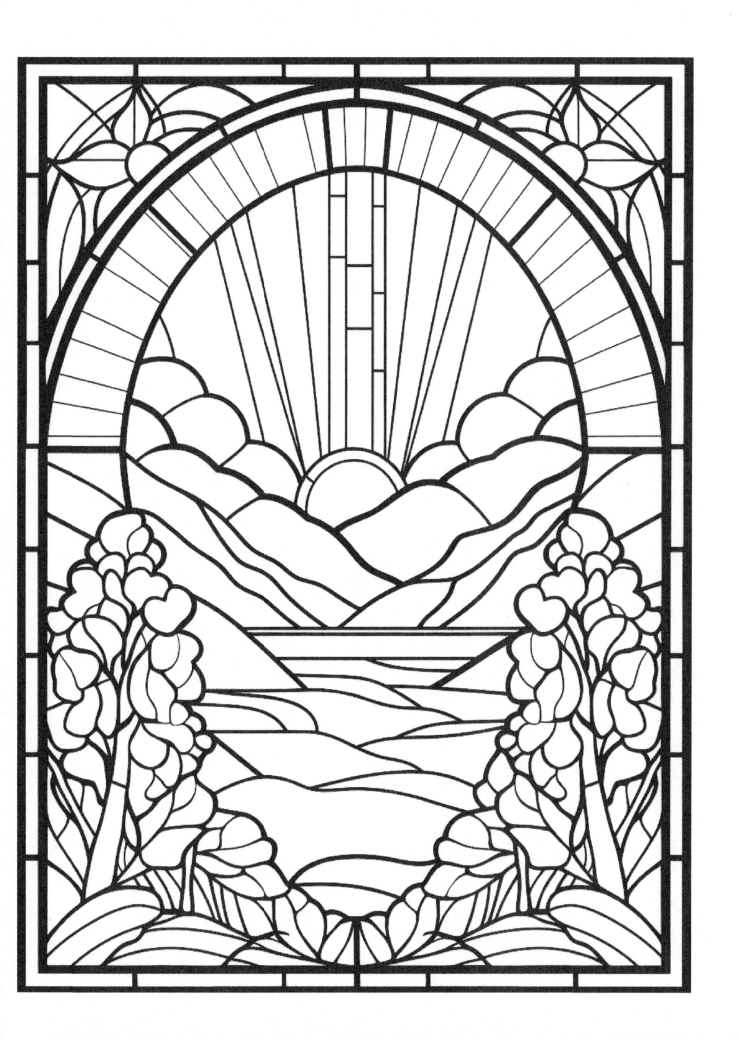

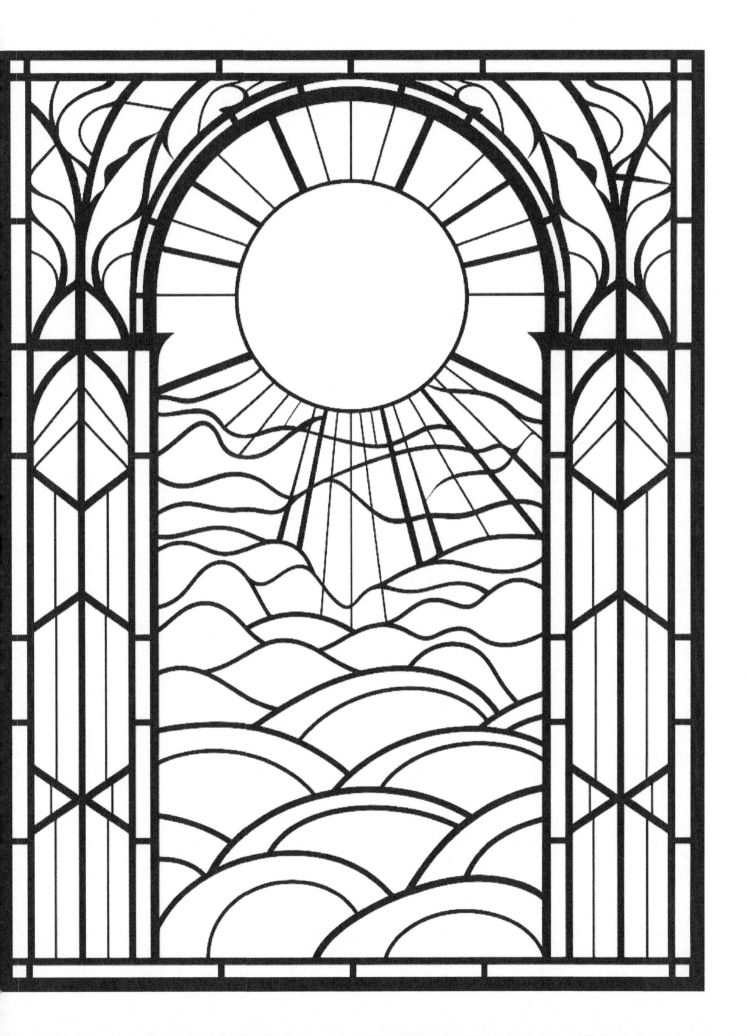

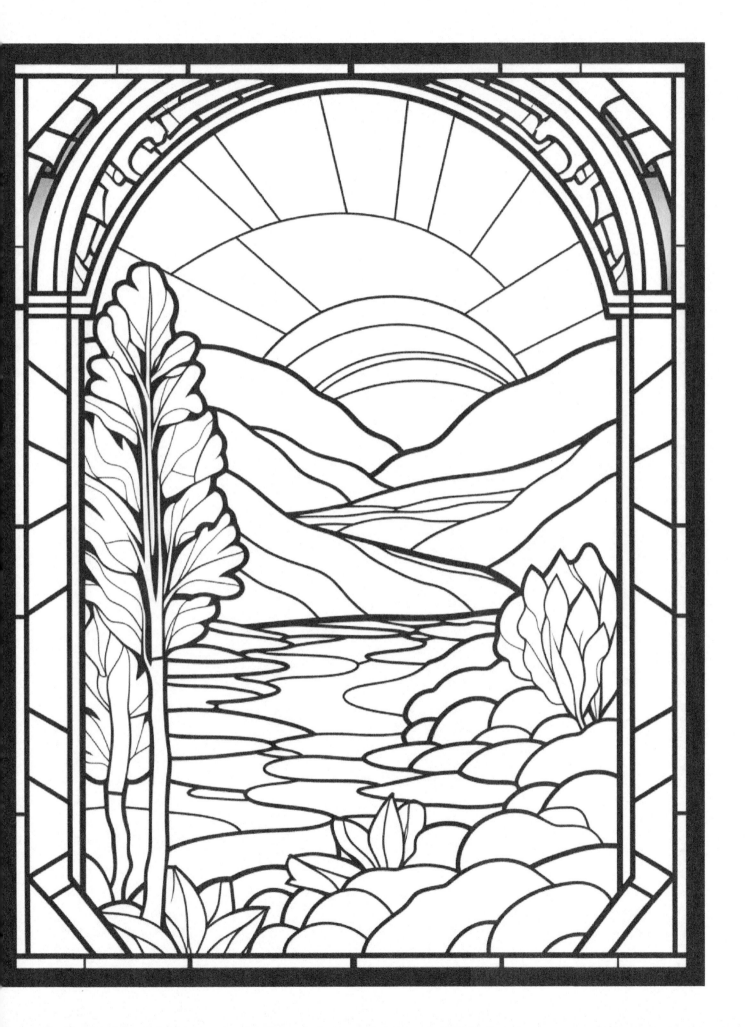

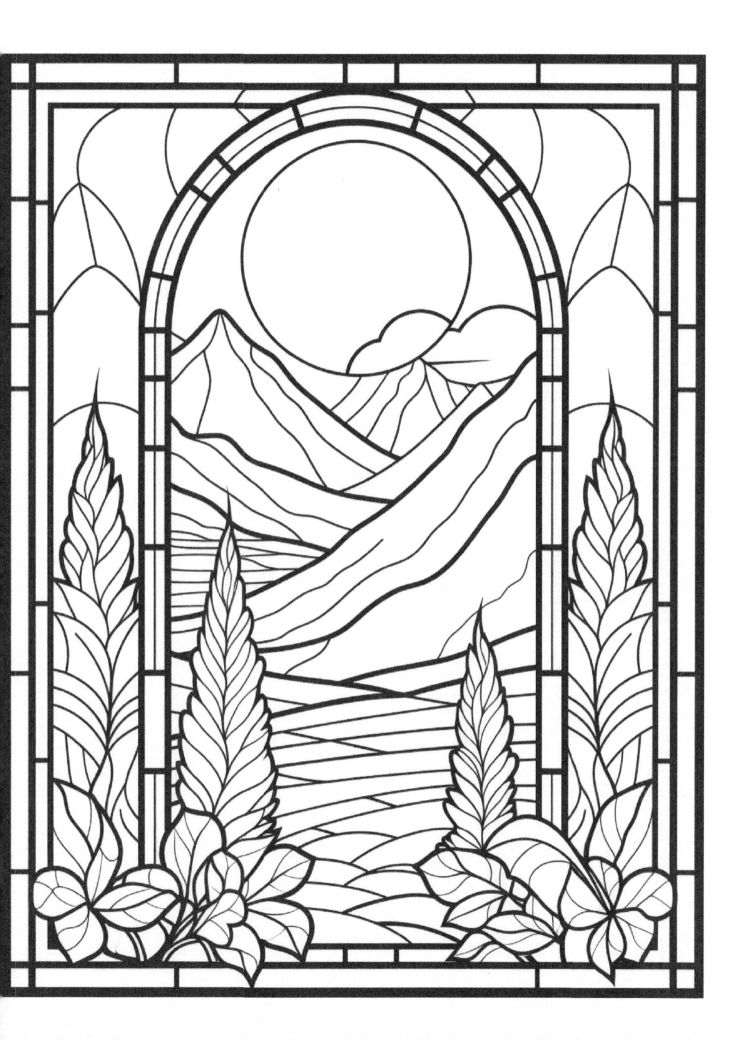

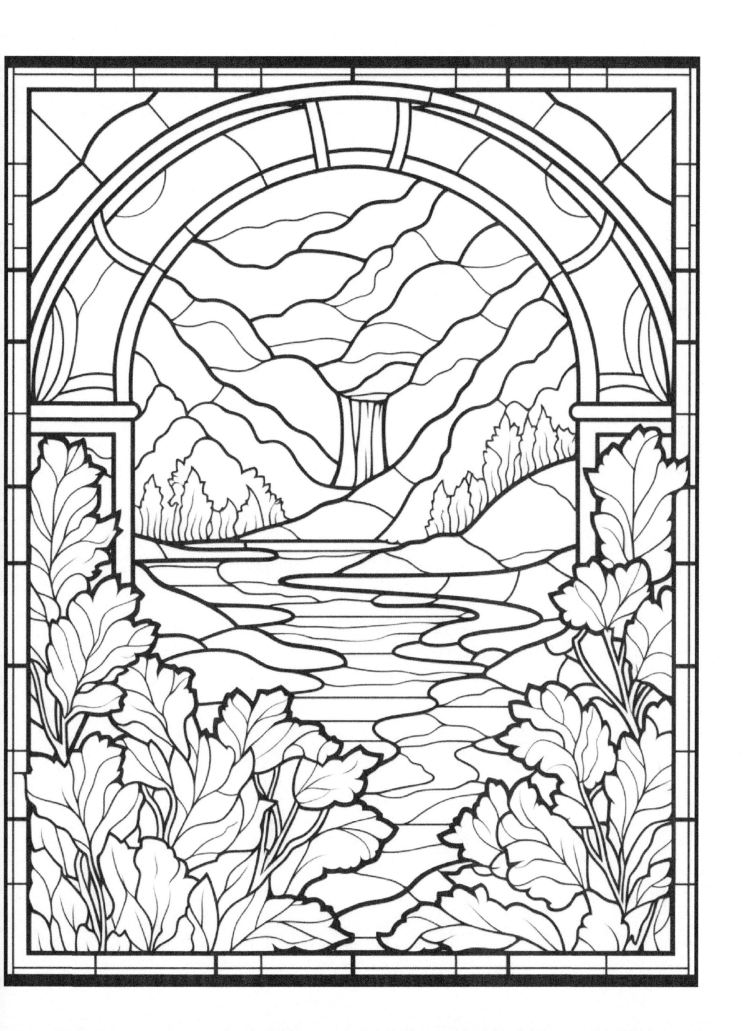

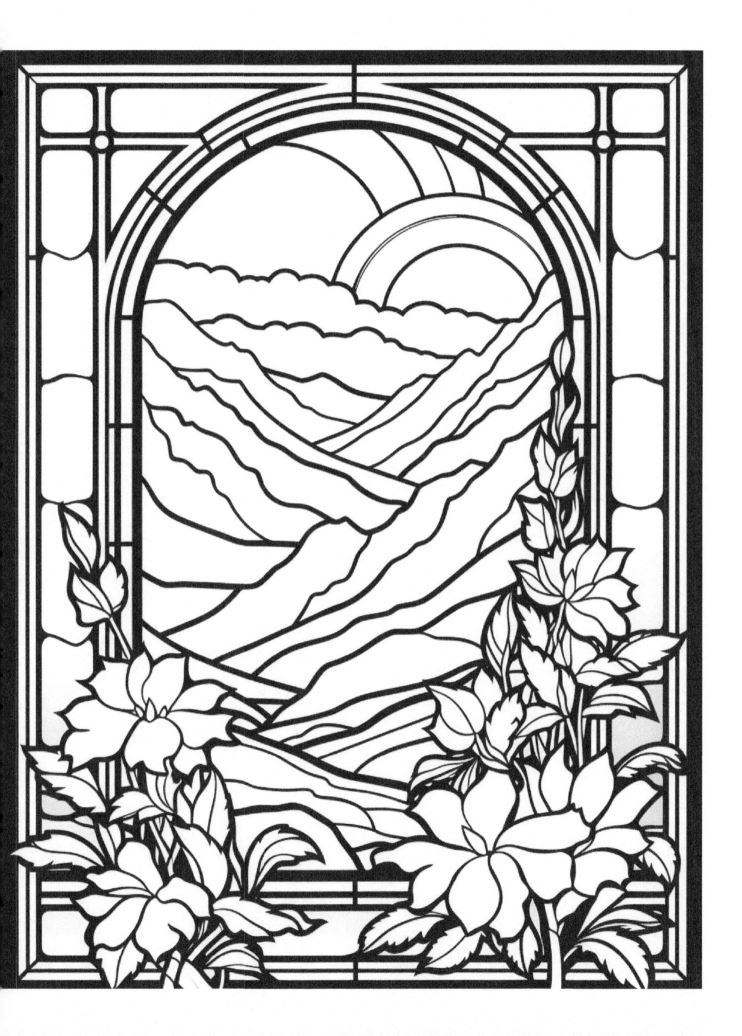

Enjoyed this coloring book?

Your feedback is much appreciated.

Leave a review by scanning this QR Code

Scan this QR code for more books by Therese Rose.

Thank you!
Therese Rose.

Printed in Great Britain
by Amazon